PLANET BANKSY

UNAUTHORIZED

First published in Great Britain in 2014 by
Michael O'Mara Books Limited
9 Lion Yard
Tremadoc Road
London SW4 7NQ

A CIP catalogue record for this book is available from the
British Library.

Papers used by Michael O'Mara Books Limited are natural,
recyclable products made from wood grown in sustainable
forests. The manufacturing processes conform to the
environmental regulations of the country of origin.

ISBN: 978-1-78243-158-9 in hardback print format

1 2 3 4 5 6 7 8 9 10

www.mombooks.com

Designed and typeset by Greg Stevenson and Billy Waqar

Printed and bound in Singapore by Tien Wah Press

PLANET BANKSY

UNAUTHORIZED

THE MAN, HIS WORK AND THE MOVEMENT HE INSPIRED

Compiled and Introduced by KET

Michael O'Mara Books Limited

**This book is dedicated to
the memory of P183 (Pavel 183).**

You are gone but will not be forgotten.

Foreword

Around the world the prolific street artist and provocateur Banksy is revered for his humour, creativity and the messages contained in his art and stunts. He is an example of a complete outlaw artist who has taken it upon himself to share ideas that on one hand seem radical, but on the other are obvious and shamefully truthful. He comes from a lineage that is one part graffiti writer – with a penchant for taking over public walls – and one part social activist, realizing that there are problems in the world that need to be faced and discussed and sometimes ridiculed. His images target governments and police for their own criminal and outrageous behaviour, war and its insanity, poverty, the cult of celebrity, and even adults for forgetting their childhood dreams, among other things.

Banksy and many of the other artists featured here began making art as graffiti writers, cutting their teeth on the streets and learning the basics of stealth, spray painting, and dealing with the general public – at night. However Banksy's departure from the graffiti world of stylized letters into one in which he learned to use his wit to paint elaborate stencils (like fellow artists Nick Walker, Blek Le Rat, and Jef Aerosol before him) and construct clever pranks while at the same time leveraging it to sell art was a coup for him in the art world. His success selling prints of the same types of images as he paints in the streets provides him with the economic means to push his ideas further. He has such a strong market for his art that his images have been bootlegged on merchandise and copied by pranksters the world over.

His travels have taken him around the world, touching down to leave provocative messages in places like Israel's West Bank and New Orleans in the United States post-Hurricane Katrina, sparking dialogue and opening up a critique of the human condition. These same travels have also established Banksy as a leading figure in the international community of street artists. His paintings, his books, his film, and his relentless bombing have created an art celebrity that has inspired both established and new artists the world over.

The artists featured in these pages are, like Banksy, talented and disciplined in their approach to creating art and then in turn taking it outdoors and sharing it with their cities. The images that you will see are the end process of their artistic creations; art that is born in their homes and studios, taking countless hours to imagine and ultimately create. For most there is a scouting process in order to find the right location to share their art – more hours invested. Finally once the pieces of art are ready they are introduced into the streets to live for a limited time. The lifespan of the art pieces featured in this book is typically short. Many are cleaned off, erased, covered, and destroyed within days of their creation. Some lucky ones, perhaps the sanctioned ones (of which there are few) tend to last much longer but I would argue that their impact isn't as strong as the art that is illegal and that we can encounter spontaneously. Of course each artist has figured out a way to navigate the streets in their cities in order to get their art out there, and the circumstances are different from city to city. What works in Buenos Aires and Athens might not work in London or Geneva.

All the artists featured in this book are activists performing interventions with public space in order to spread their messages to the general public – at the risk of arrest. They share a common desire to share ideas in order to bring happiness, awareness, and attention to the world what it is that they feel inside of them. The artist named Ender explains, 'The city is ours. I want to surprise the passers-by; they wake up one morning and discover one piece

on the walls. I want them to think, but most of all to smile, to amaze, to [feel] surprise, in a kindly way; I don't take action against the city, but rather for it and with it.' Nazeer from Cairo adds, 'I started painting in the streets when I realized that there is another medium to practice my freedom of expression and to fight the circumstances, and it all happened because suddenly the police force wasn't strong as it has always been. Art was never my intention – it was all in the name of activism.'

The artwork featured here focuses on common themes that have been explored by Banksy and others. It is no surprise that police, government and the law is a subject for many artists including Dede (Israel), Keizer (Egypt), Hogre (Italy), and Mogul (Sweden). Civil unrest, war, and peace is another popular theme for artists worldwide including Camo (Australia), Soon (Germany) and Icy and Sot (Iran). #codefc (England) has treated this theme as one of his main projects. Others like Wild Drawing (Greece) explore the issues of poverty and unemployment that are all too real in his hometown of Athens. Yet, for all the seriousness that these artists bring to the streets there are also a slew of those who inject fun and humour with their art including Ender (France), Ozi (Brazil), and Zuk Club Art Group (Russia) whose dwarf series is very clever. Yet another popular theme is one that brings a sense of playfulness to the urban jungle many of us live in. Fantastic animals come to life and are ridden by children as in the art of Run Dont Walk (Argentina), gigantic animals dwarf pedestrians in the art of Toxicómano Callejero (Colombia), and Be Free (Australia) paints a little girl that among other things doodles on the wall in a very carefree way. Celebrities, heroes, martyrs, angels, death and many more themes fascinate the artists and have made for great art.

I do hope you enjoy the art on the walls that the artists are sharing with us all. I find it amazing to witness and I am very honoured to present their work to you.

Now let us begin.

KET

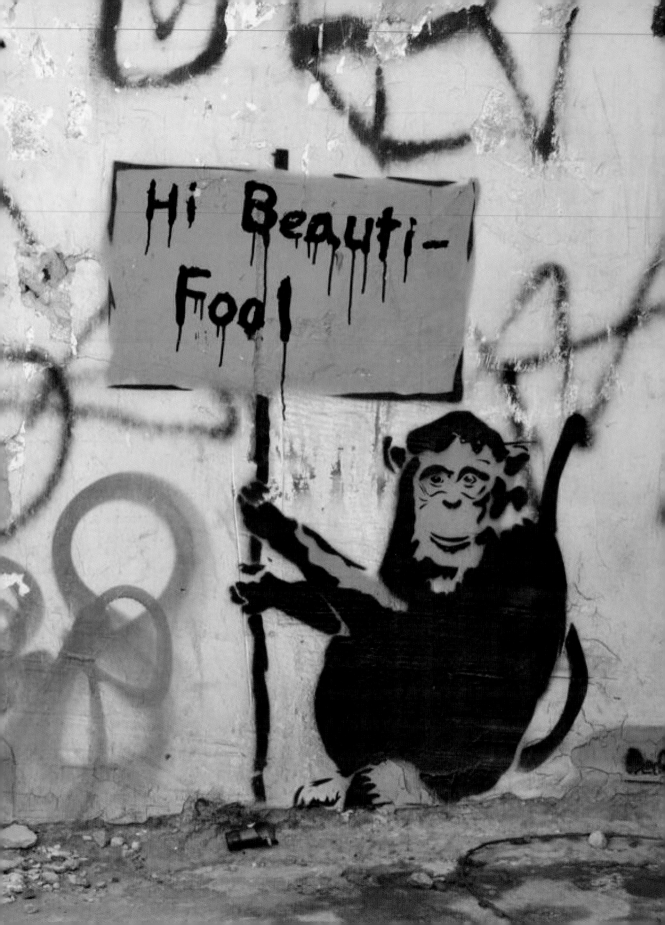

contents

Left: Dede, Tel Aviv, Israel, 2011.
Photo by Milli Katz

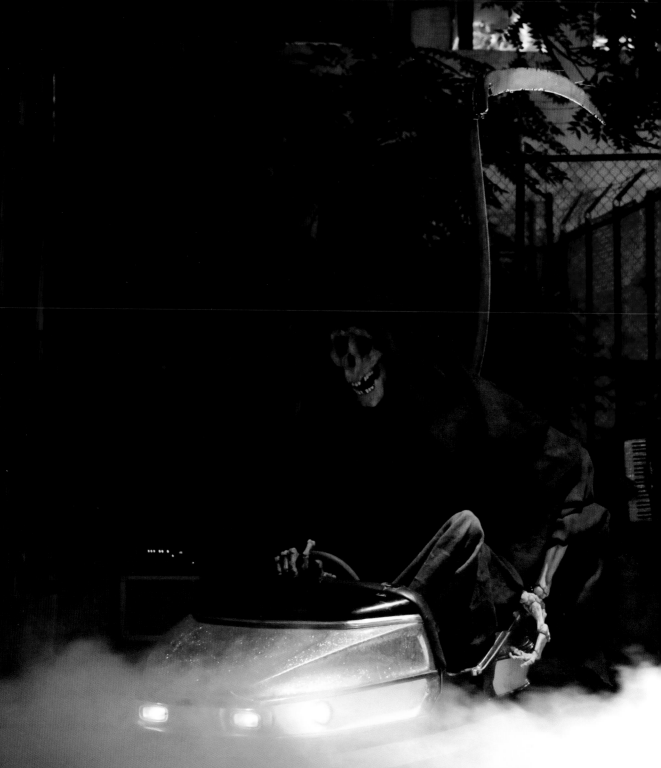

angels & demons

The fascination with and use of angels, demons and death in the arts is nothing new – our own mortality seems to call for it. Furthermore, the power of religion in human society is present in the art created in the streets, whether to celebrate an aspect of mythology, as seen in the abundant angel imagery that is used by many artists, or to use the stories to create a critique about religion and life.

The use of demons and images of skulls and death is another sign of modern times and it speaks to our collective fascination with death and with artists creating imagery that is frightening and scary to the viewer. In the streets such representations draw an immediate attention to the art and this is useful to the artists who are seeking to attract attention.

Left: Banksy, video still, New York City, New York, USA, 2013. Photo by Ray Mock

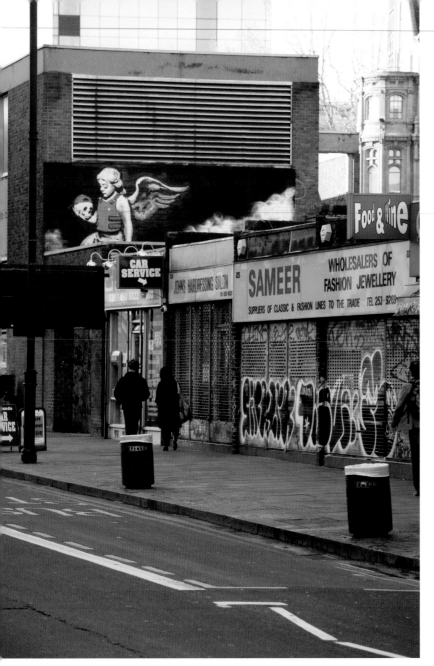
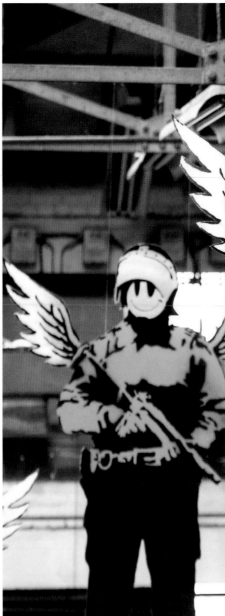

Above left: Banksy, Ozone's Angel, Old Street, London, England, 2008. ©*ArtAngel / Alamy*
Above right: Banksy, London, England, 2003. © *REX*

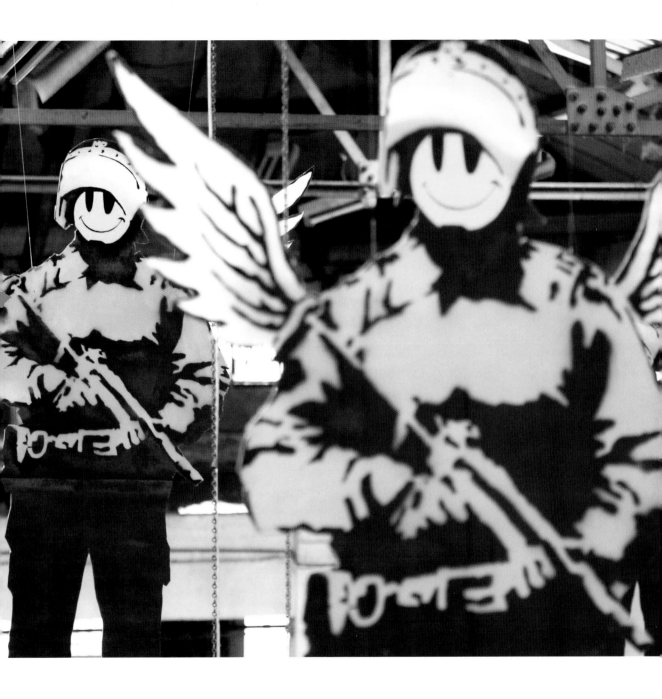

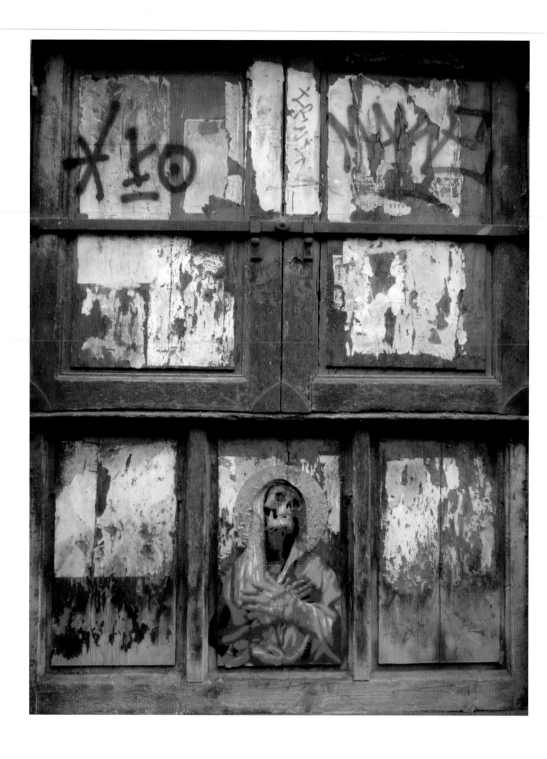

Above: Ender, Annonciation, Florence, Italy, 2013.

Opposite
Above: ADW, Valentine's Day Massacre, Dublin, Ireland, 2013.
Below left: Skullphone, Los Angeles, California, USA, 2011.
Below right: Run Dont Walk, New York, NY, USA, 2012.

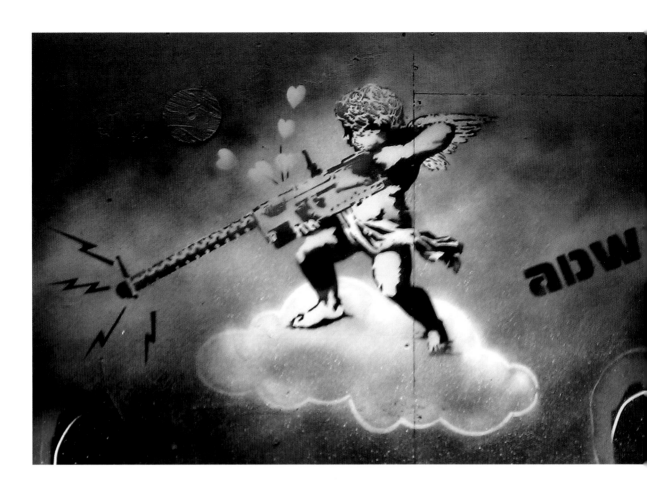

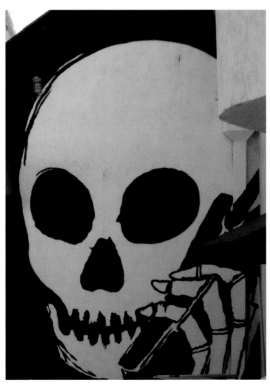

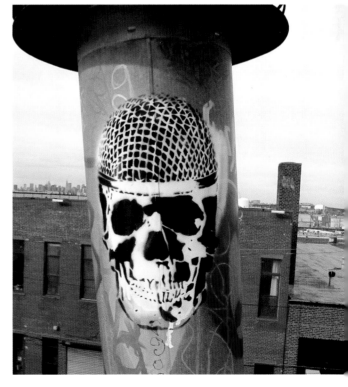

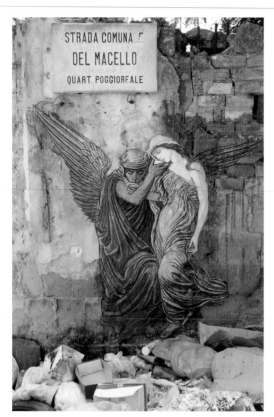

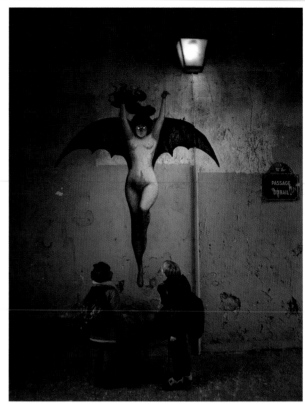

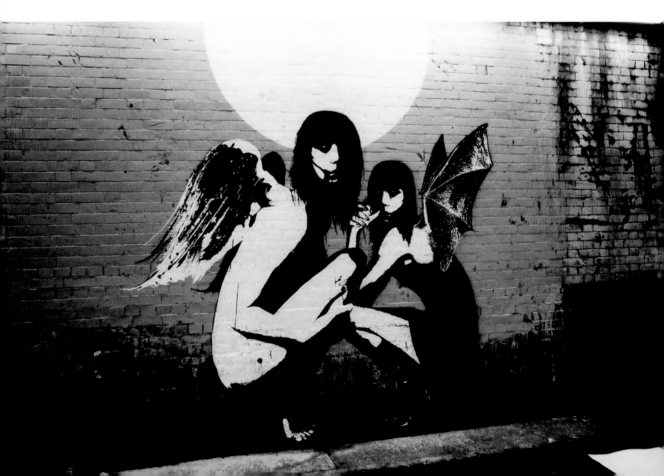

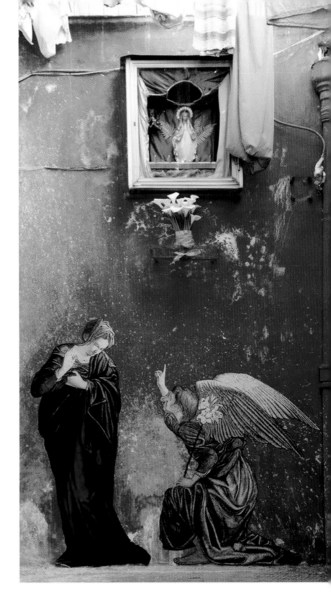

Right: Žilda, The Annunciation (adapted from the original work of Orazio Gentileschi), Naples, Italy, 2012.

Opposite
Top left: Žilda, The Cup of Death (adapted from the original work of Elihu Vedder), Naples, Italy, 2011.
Top right: Žilda, Batwoman (adapted from the original work of Albert Penot), Paris, France, 2012.
Below: Eelus, Cans Festival, London, England, 2008.

'There is no particular significance to my paintings. If I draw angels or winged creatures, it does not make me a mystical person. What motivates me is to speak about allegorical things, things that escape rationality or provoke strange interpretations. The street is also a place where you can surprise, where you can lead a passerby to something unexpected in an unexpected place.'

ŽILDA

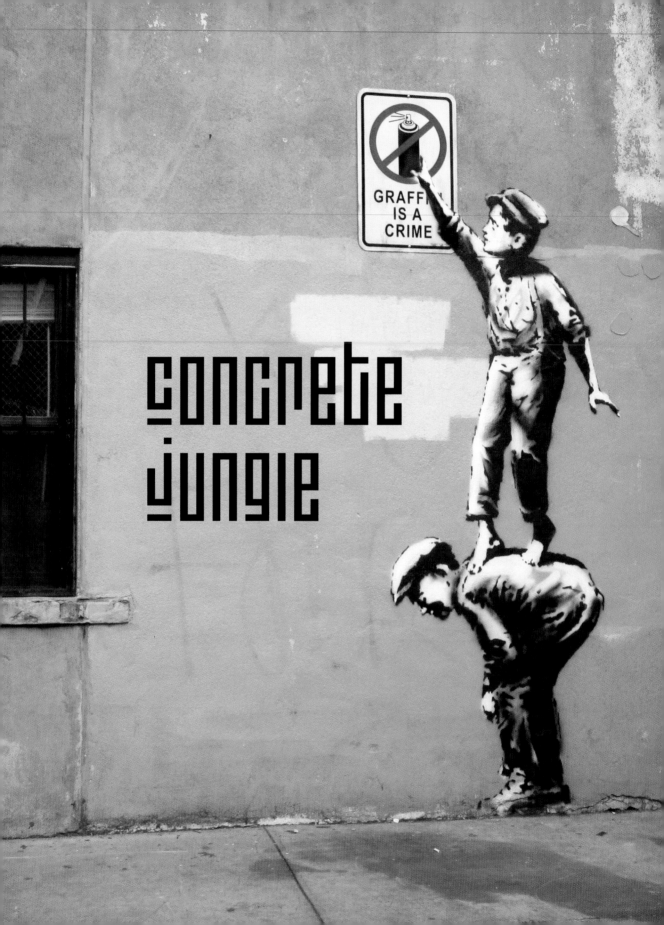

Today, humans continue to expand cities across the face of the earth and destroy jungles, forests, and everything else in order to grow and extract natural resources for the planet's hyper-consuming and growing population. For the first time in the history of man more people live in cities than in rural communities. These urban metropolises teeming with people and life have created an industrialized work-driven society where people are born to become the next generation of workers feeding the capitalist system that maintains order.

These concrete urban jungles are playgrounds for kids and imaginative adults who have resisted the pull of monotony. Graffiti writers and street artists have been rebelling against the boredom and pale coloured walls for decades by painting them with multicoloured versions of their aliases and, more recently, with images that convert the city walls into an artist's playground covered by imaginative ideas painted in stencils, posters, murals and other forms of expression.

Artists like Banksy, Run Dont Walk and others featured here are infusing fun and expressing their inner child – sometimes as literal children on the walls. The images provoke us to celebrate life and remember that the fun that we experienced as children is still alive with us today. In the artists' takeover of the city their imagination has brought to life animals, both real and mythical, on the walls. Farm animals, dinosaurs, unicorns, mermaids, are all around us thanks to artists and their cavalier and daring art ways.

Left: Banksy, New York City, New York, USA, 2013. Photo by Ray Mock

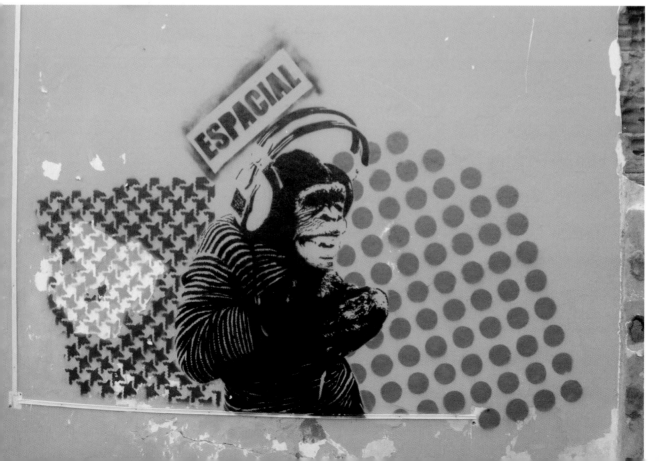

'Street art should be free, with people creating without thinking about money, the future or shows at elegant galleries. This is why we don't sign our pieces, if I put my name I became "the author", with that simple act I claim credit and attention. If you don't sign your piece, anyone in the city becomes a suspect of having done it, even that guy beside you waiting for the bus.'

GONZALO FROM THE COLLECTIVE BS.AS.STENCIL

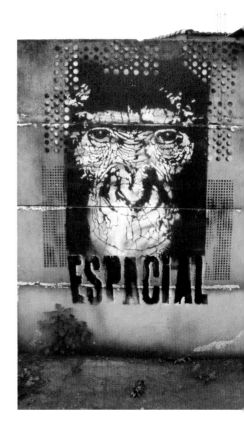

Left: BS.AS.Stencil, Tudela, Spain, 2011. Photo by Ana Alvarez Erricalde
Below left: Matias Espacial Picón, Mono Floripa, São Paulo, Brazil, 2012.
Right: Matias Espacial Picón, Mono Negativo, São Paulo, Brazil, 2009.
Below: Matias Espacial Picón, Rual, São Paulo, Brazil, 2012.

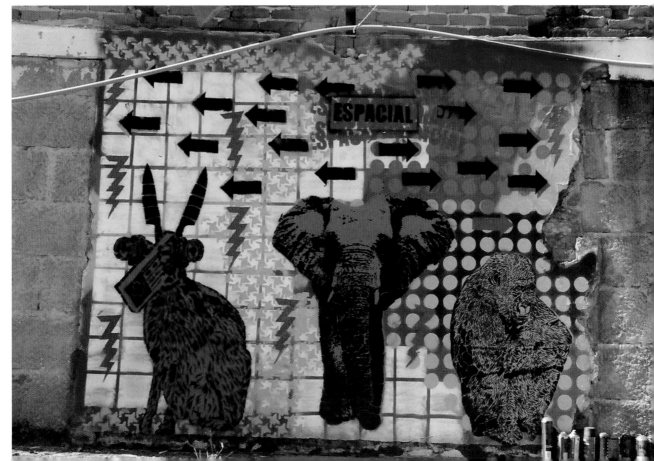

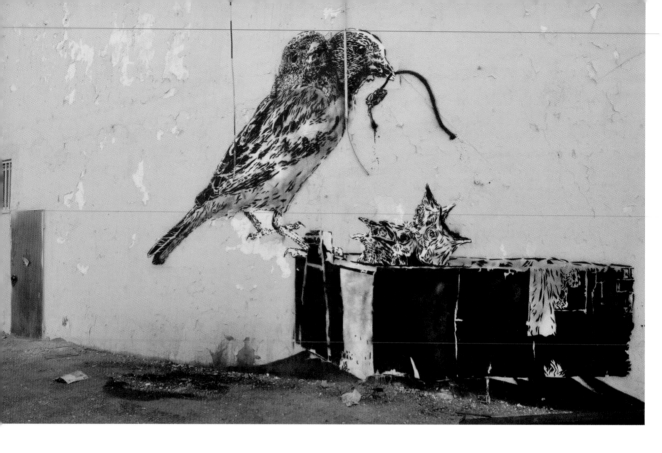

Above and Below: Dede, Tel Aviv, Israel, 2011. Photos by Milli Katz

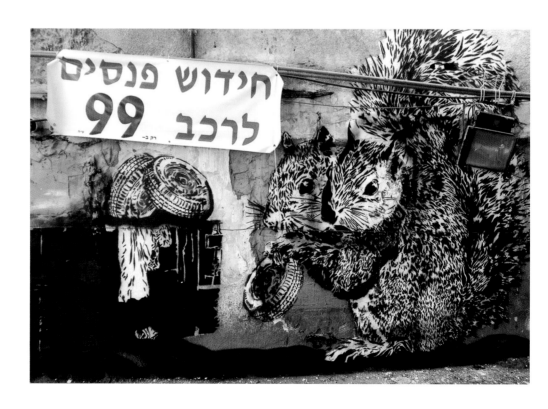

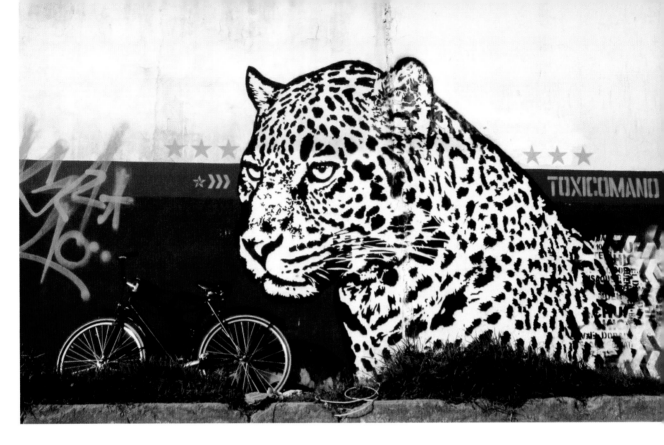

Above: Toxicómano Callejero, Bogotà, Colombia, 2011.
Below: Toxicómano Callejero, Lima, Peru, 2013. Photo by KET

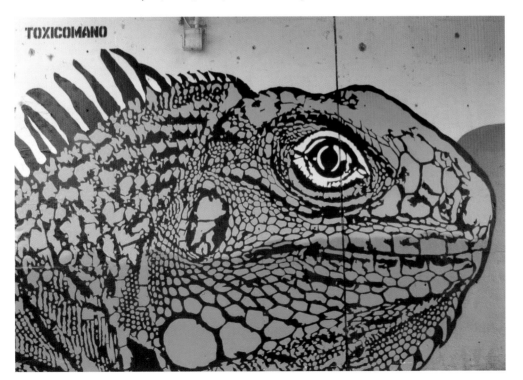

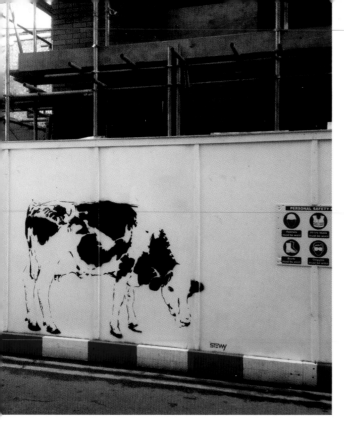

Left: Stewy, Liverpool, England, 2011.
Below: Banksy, London, England, 2003. © *REX*

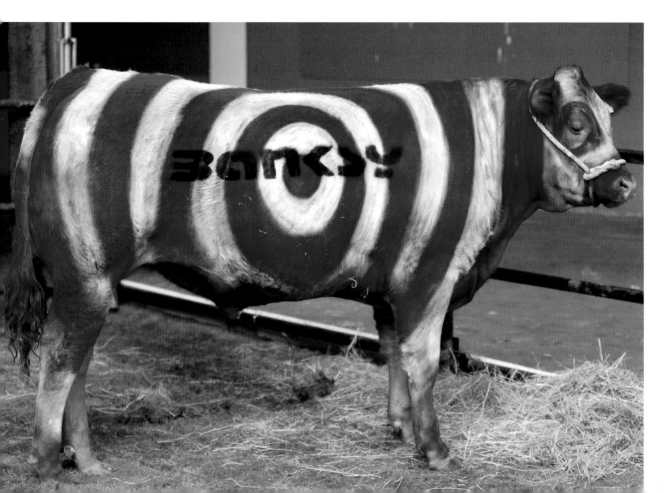

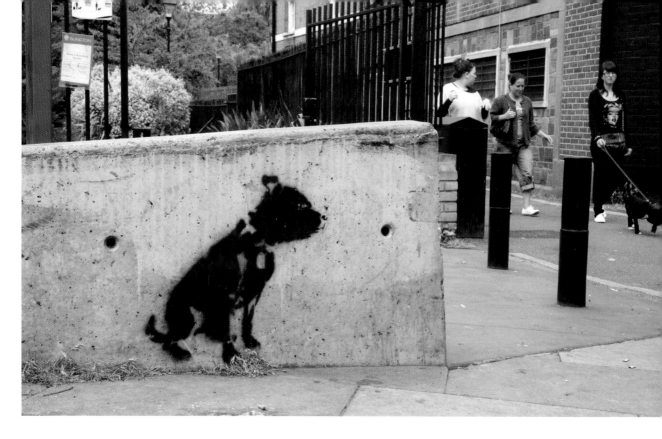

'My images are almost like "ghost" images, a pause in time. I like the animals taking over the cities, reclaiming their natural habitat amongst the concrete and the tower blocks, similar to putting "city boys" in a field.'

STEWY

Above: Stewy, Camden, London, England, 2012.
Right: Stewy, London, England, 2011.

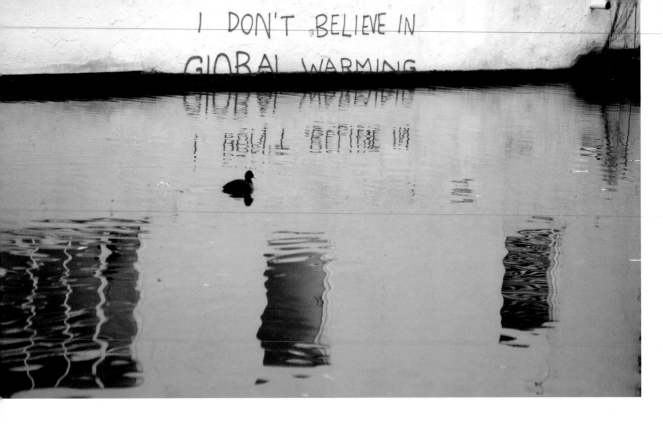

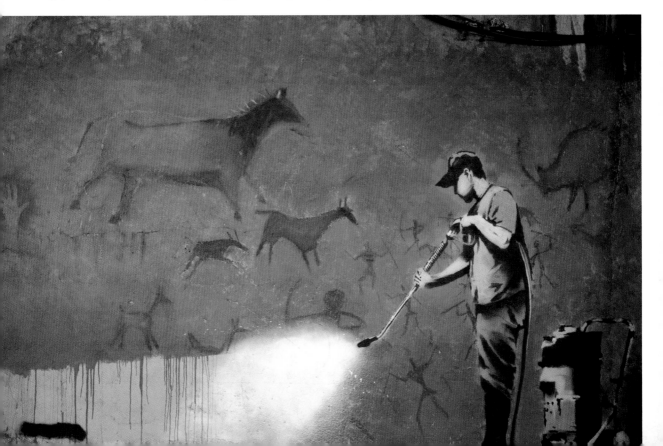

Above: Unknown, Camden, London, England, 2009. © *Jeffrey Blackler / Alamy*
Below: Banksy, London, England, 2008. © *Roger Cracknell 01 / classic / Alamy*
Right: Canvaz, www.canvaz.com, Diggin for Gold, Dublin, Ireland, 2012.

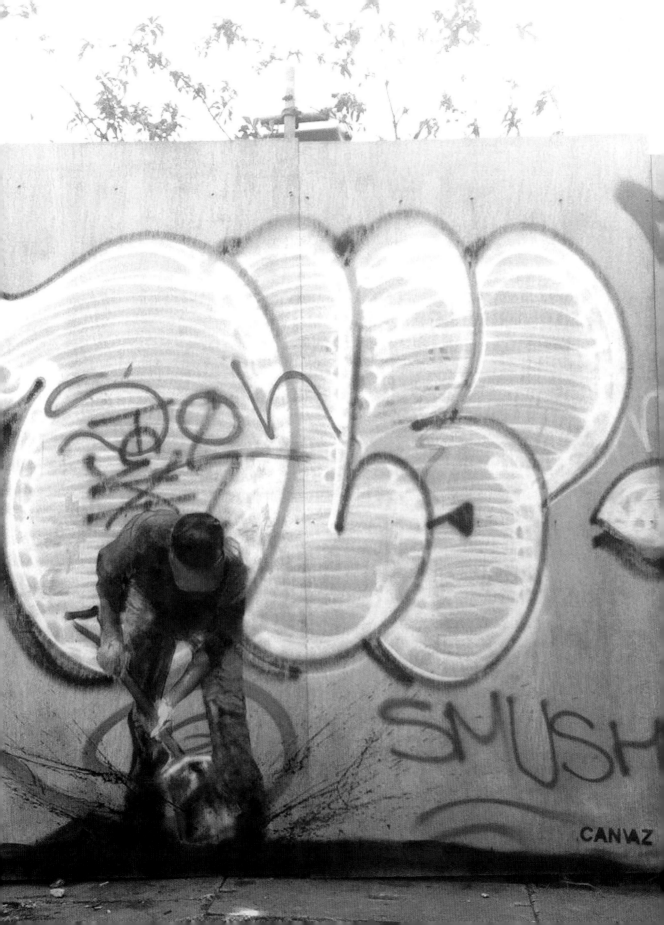

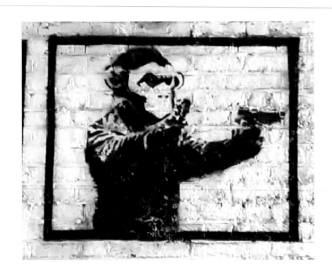

Above: Banksy, Shoreditch, London, England, 2007. © *Sophie Duval / EMPICS / PA Images*
Below: Zabou, The Revenge of Nature, Weston-Super-Mare, England, 2012.

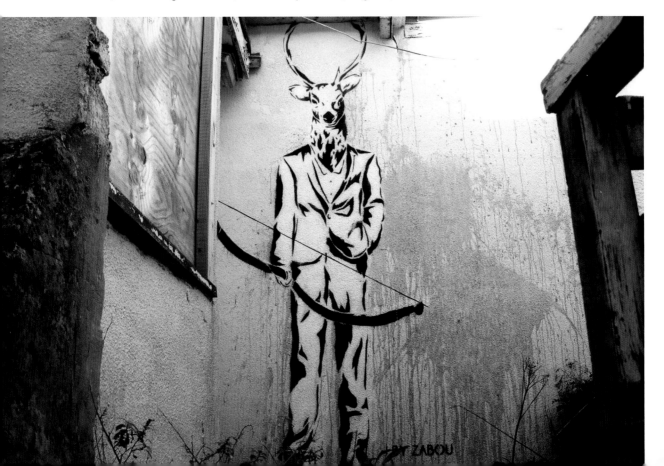

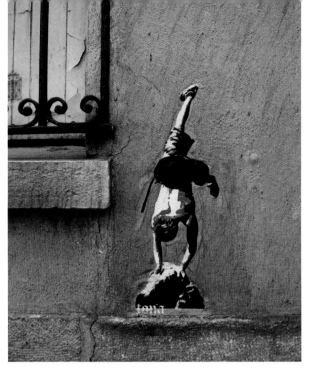

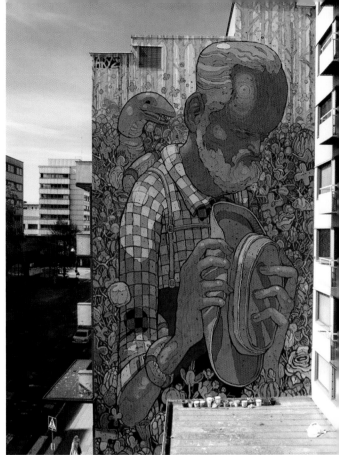

Above: Tona, Paris, France, 2012.
Right: Aryz, Turku, Finland, 2011.
Below: Icy and Sot, Chicago, Illinois, USA, 2012.

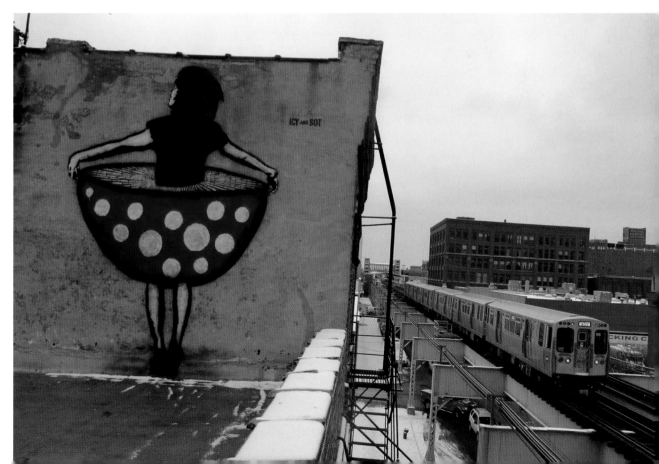

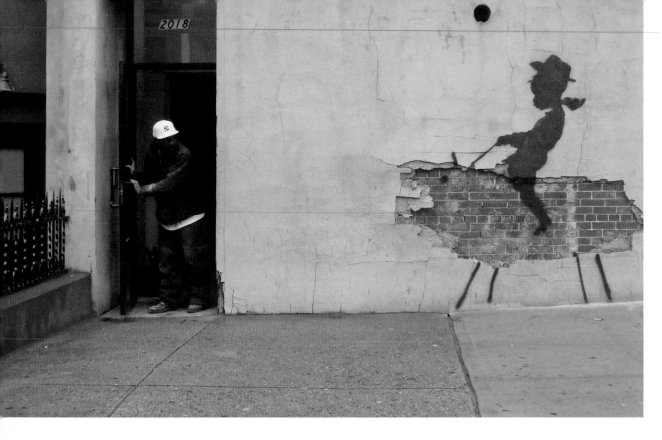

Above: Banksy, Bronx, New York, NY, USA, 2008.

Below: Banksy, London, England, 2004. © *Barry Lewis / Alamy*

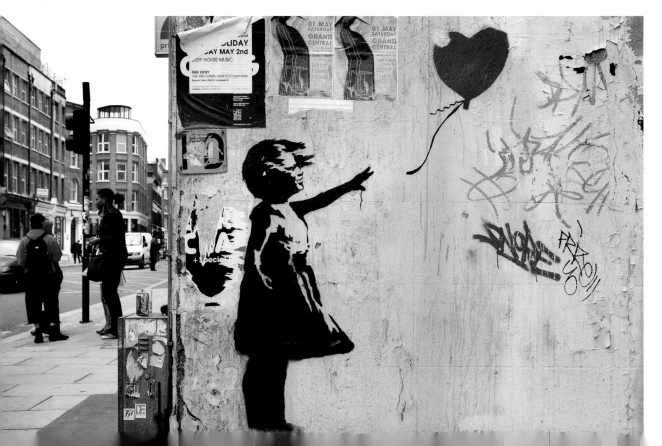

'The images I've painted in the past year they have to do with something ludicrous, of children playing, but always using scale and different animals to the ones people might expect. I don't really know what got me to have this aesthetic but I am interested in rescuing the innocence of childhood games.'

RUN DONT WALK

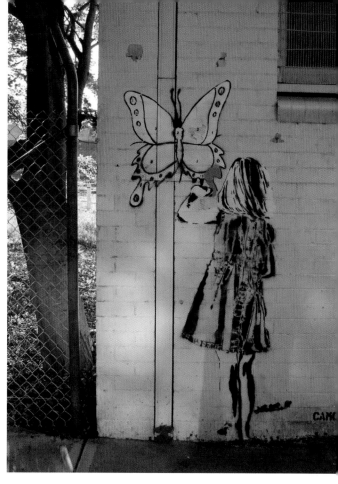

Right: Camo, Waterloo, NSW, Australia, 2012.
Below: Run, Dont Walk, Buenos Aires, Argentina, 2012.

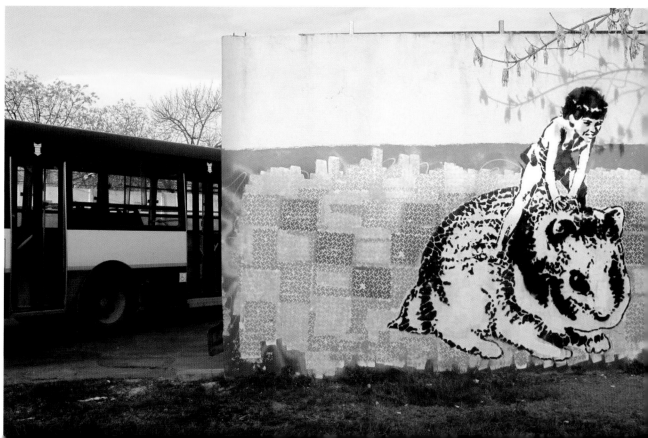

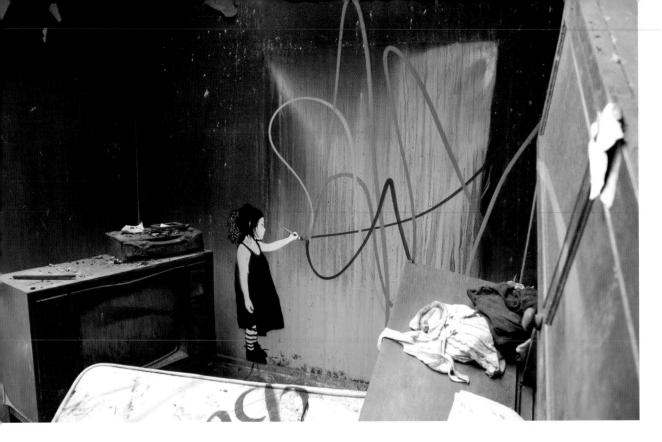

Above: Be Free, abandoned house,
Melbourne, Australia, 2012.
Right: Unknown artist, Bristol, England, 2009.
Photo by Aaron R T Smedley

'I love dirty gritty walls or
spaces that are too plain
and they just need to be
messed with.'

BE FREE

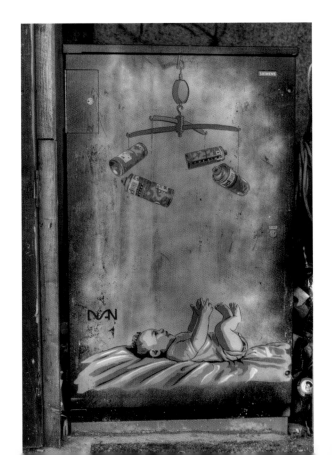

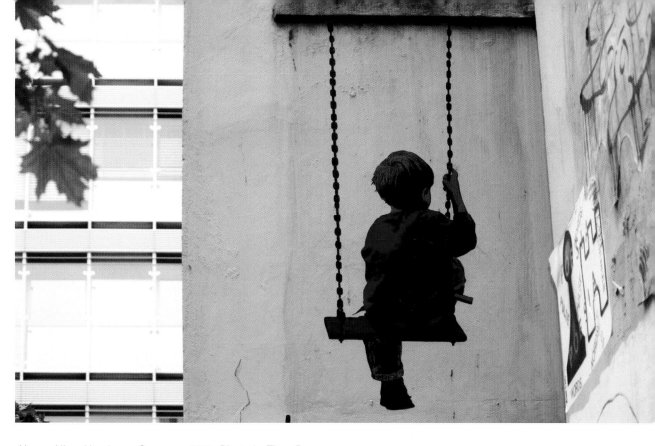

Above: Alias, Hamburg, Germany, 2012. Photo by Theo Bruns
Below: Camo, Pagewood, NSW, Australia, 2012.

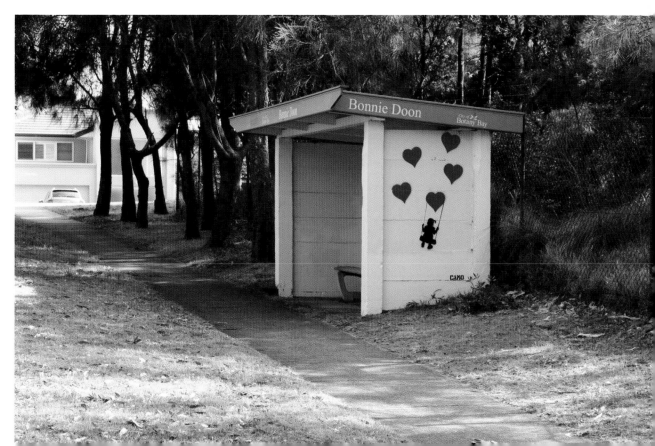

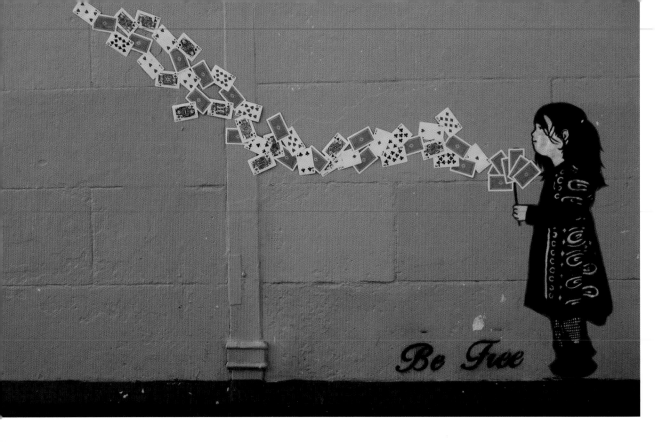

Above: Be Free, Melbourne, Australia, 2011.
Below: Icy and Sot, Mazichel Forest, Iran, 2012.

'Being a street artist is similar to being an actor, my works portray people, scenes, theatre. I have to create a scenario to give a meaning to the stencils. Once the work is pasted up, it might be short lived. It becomes the property of passers-by who will (or won't) look at it. It will be ripped off the wall, stolen sometimes or buffed but I hope it will have put a smile or an emotion to whoever looked at it.'

ENDER

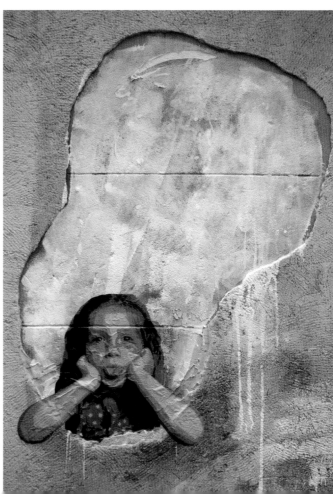

Above: FRZ, Question Mark, Tabriz, Iran, 2012.
Right: Ender, Marseille, France, 2011.

famous
faces

Those of you who draw fake moustaches on photographs of celebrities in newspapers clearly understand the notion of subverting the celebrity image and poking fun at society's fascination with celebrity status. Street artists are masters of this humour and take the fun to another level where no one is safe – not royalty, or politicians, or the deceased, or even Jesus Christ himself.

You might have already seen Banksy's take on Queen Elizabeth but around the world there is an impressive amount of celebrity image manipulation and even some fan-based behaviour, as in the case of artists posting images of their favourite celebrity or even adopting the famous person's name. Not even Banksy himself is safe from ridicule and the art in the streets.

Some artists like Cryptik have adopted images of famous people in order to bring that person's life, story, and message back to life. Images of Gandhi, Zapata, Martin Luther King Jr and others help spread their legend and remind of us their teachings.

Left: Unknown artist, Madonna, Athens, Greece, 2013. Photo by Julia Tulke

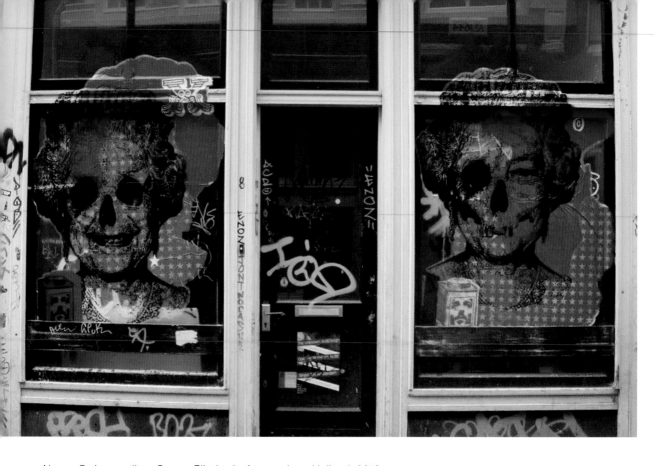

Above: Orticanoodles, Queen Elizabeth, Amsterdam, Holland, 2013.
Below Left: Pegasus, Queen Elizabeth, London, England, 2013.
Below Right: Pegasus, Liberty, London, England, 2013.

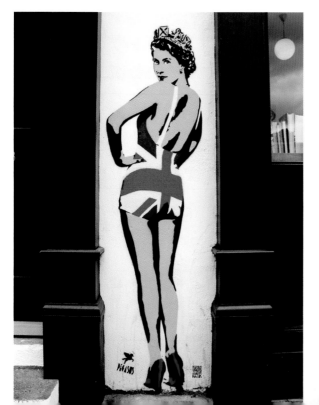

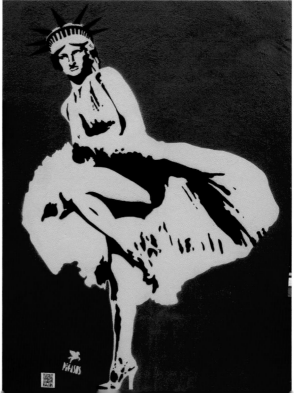

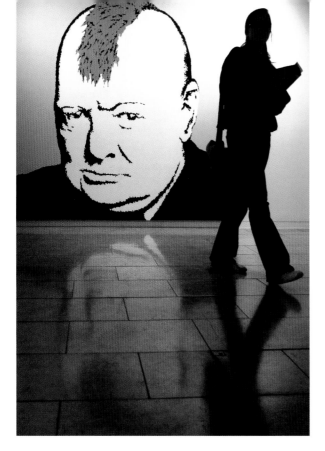

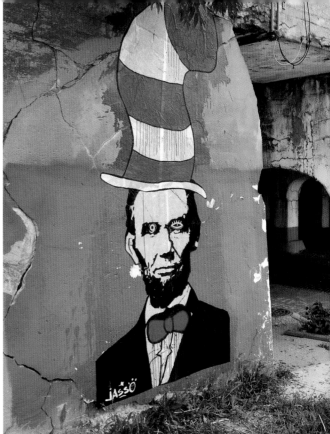

Above left: Banksy, London, England, 2007. © *Chris Jackson / Getty Images*
Above right: Jay Jasso, The Cat in the Hat (Lincoln), Chicago, Illinois, USA, 2012.
Below: Cryptik, Los Angeles, California, USA, 2011. Photo by KET

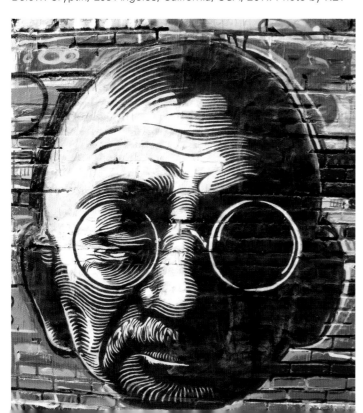

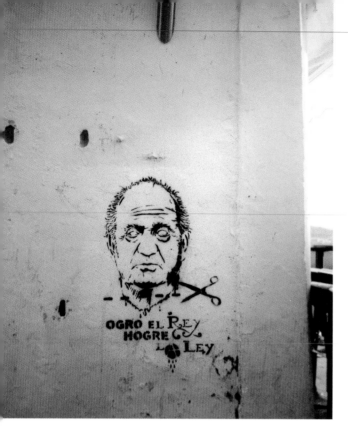

Left: Hogre, Juan Carlos, Barcelona, Spain, 2008.
Below left: Hogre, Putin, Rome, Italy, 2012.
Below right: E.L.K., Mao Zedong, Ho Chi Minh City, Vietnam, 2013.

Opposite
Above: Unknown artist, Jail Morsi, Cairo, Egypt, 2011.
Photo by Hend AbduAllah
Below: Solus, Dr. Evil, Dublin, Ireland, 2013.

'To me, celebrities are like tater tots. I hold them near and dear to my heart.'

HANKSY

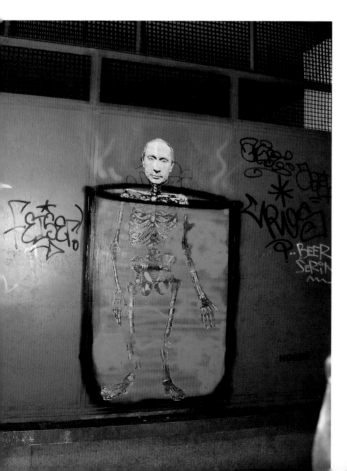

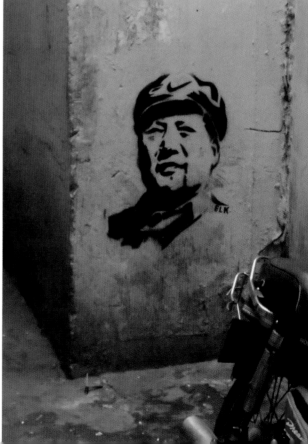

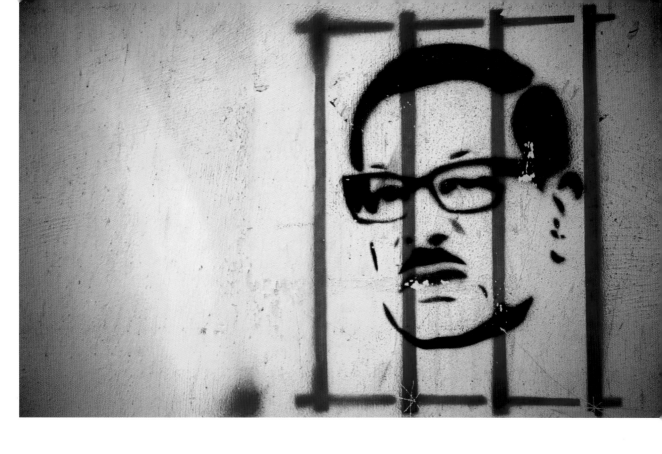
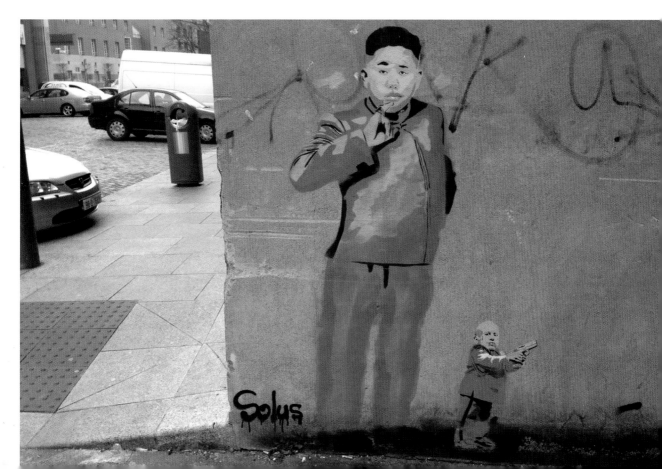

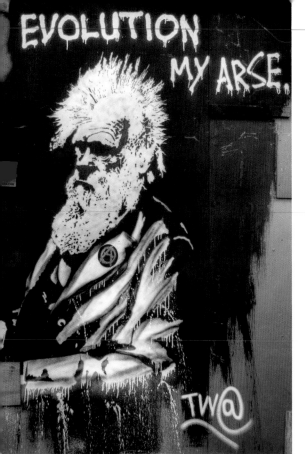

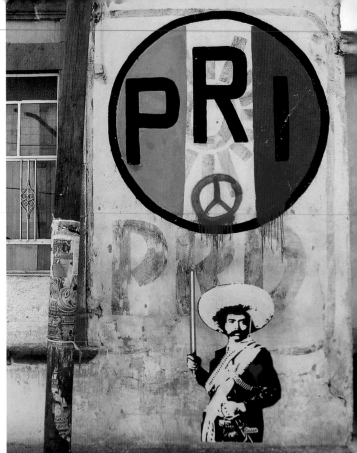

'I want people to be able to connect with the image I put out in the street, people should know that minorities are majority and the hate, racism and stereotypes will only make people stronger as a family.'

JAY JASSO

Above Left: T.Wat, Evolution My Arse, London, England, 2009.
Above Right: Jay Jasso, Jedi Zapata, Guanajuato, Mexico, 2012.
Right: Banksy, New Orleans, USA, 2008. © *Sean Gardine / Getty Images*

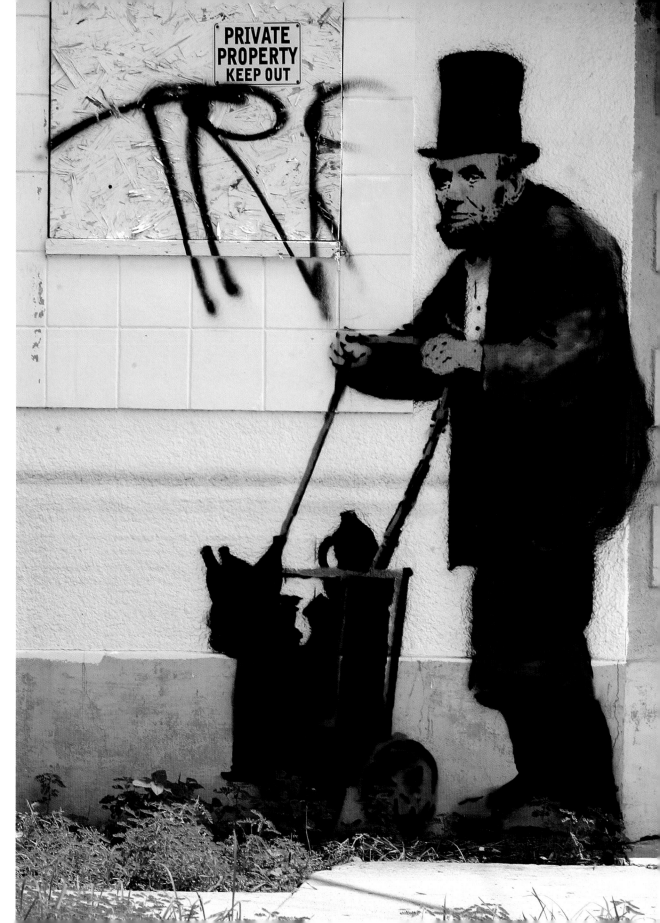

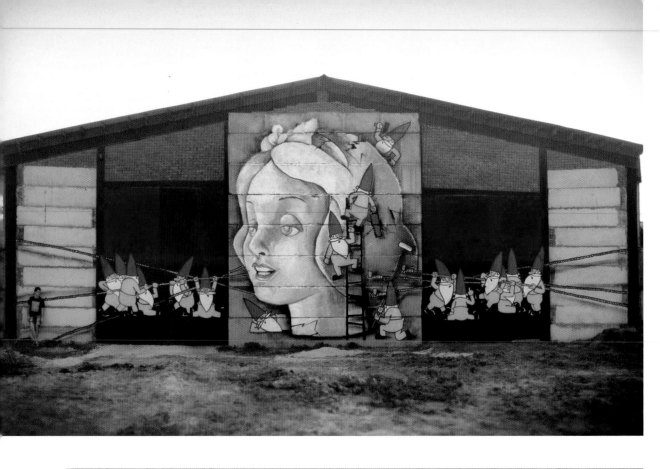

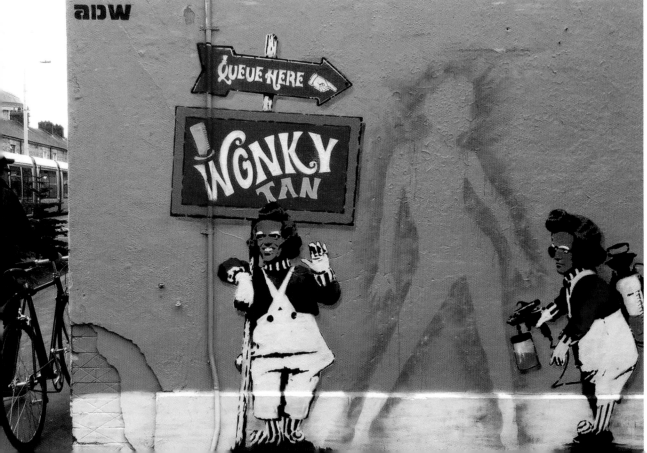

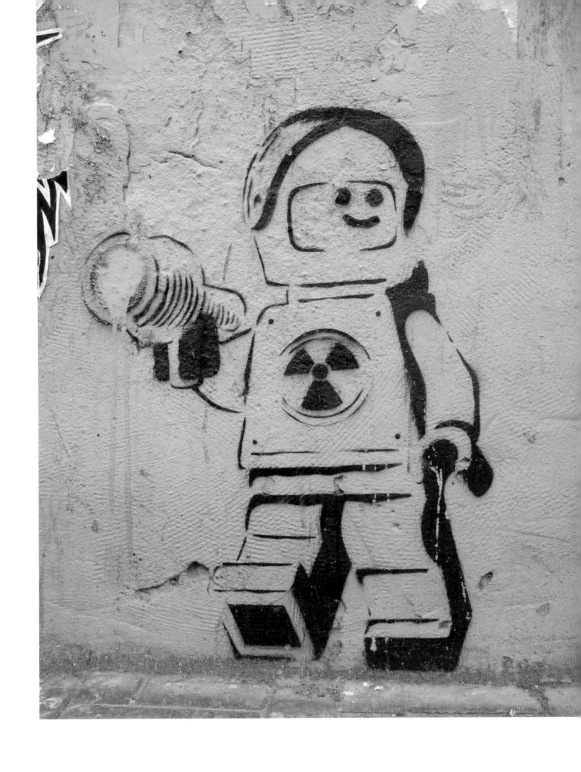

Above Left: Zuk Club, Snow White and the Dwarves, Village Zaokskiy Russia, 2012.
Left: ADW, Wonky Tan, Dublin, Ireland, 2012.
Above: Unknown artist, Nuclear Ray, Tel Aviv, Israel, 2010. Photo by Julia Tulke

Right: Pegasus, Mona Lisa, London, England, 2013.
Below left: Orticanoodles, Frida Kahlo, Barcelona, Spain, 2012.
Below right: Unknown artist, Salvador Dali, Lima, Peru, 2013.
Photo by KET

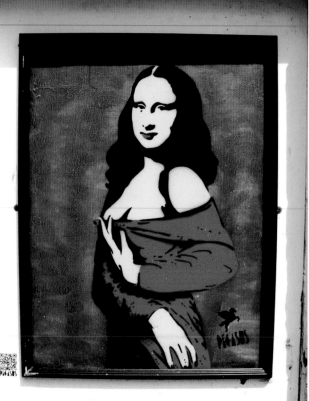

'I think it's stupid to rent public places to politicians and multinational companies that are free to bomb us with their fucking messages. As a protest of the using of public spaces I'm feeling free to paint on the street, so the medium is the first message.'

HOGRE

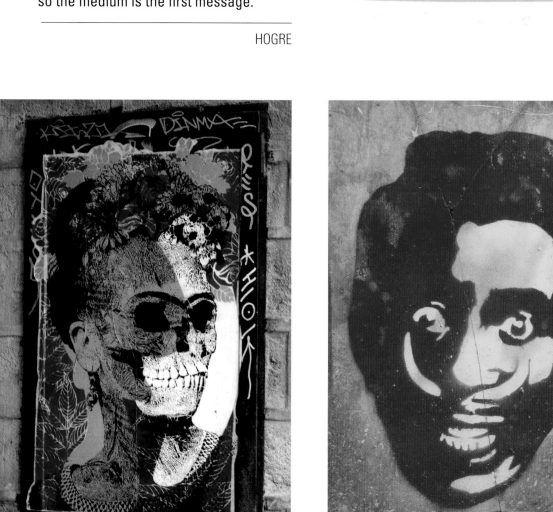

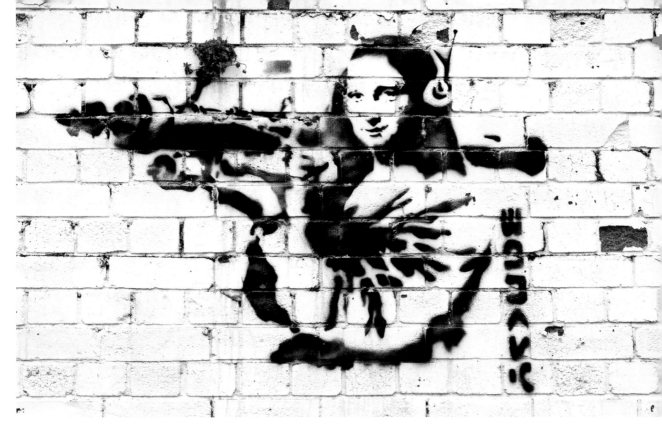

Above: Banksy, London, England, 2001. © *Chris Dorney / Shutterstock*
Below: Ozi, Pablo Picasso, São Paolo, Brazil, 2013.

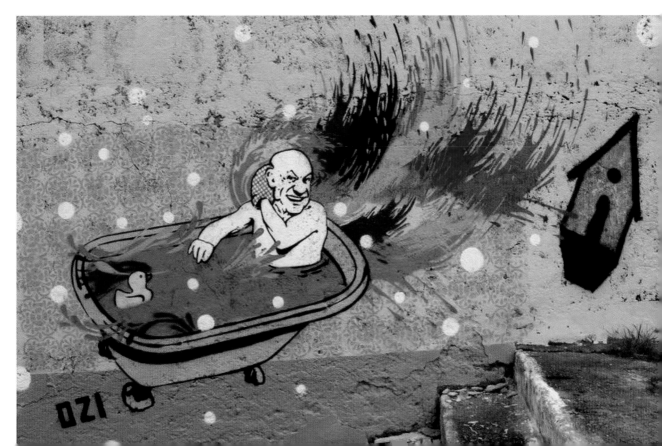

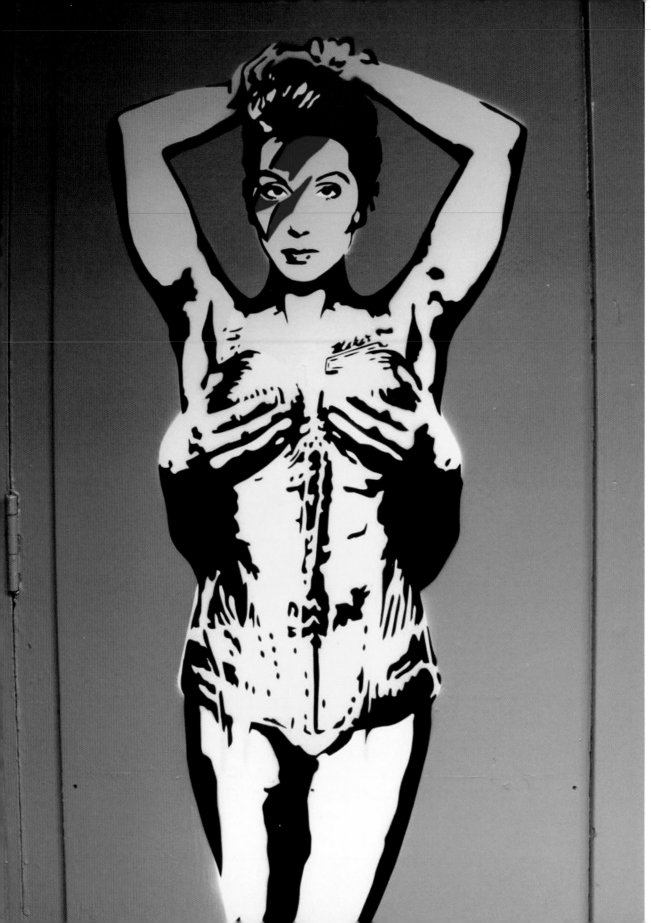

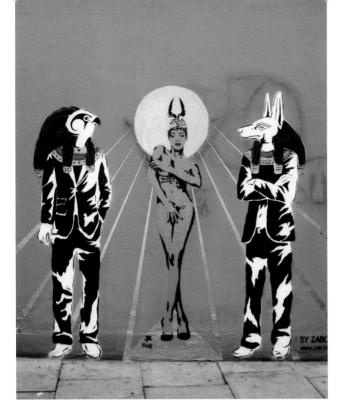

Left: Pegasus, Cher, London, England, 2013.
Above left: Zabou and Pegasus, Tribute to Rihanna, London, England, 2012.
Below: The Dude Company, Notorious BIG, Prague, Czech Republic, 2011.

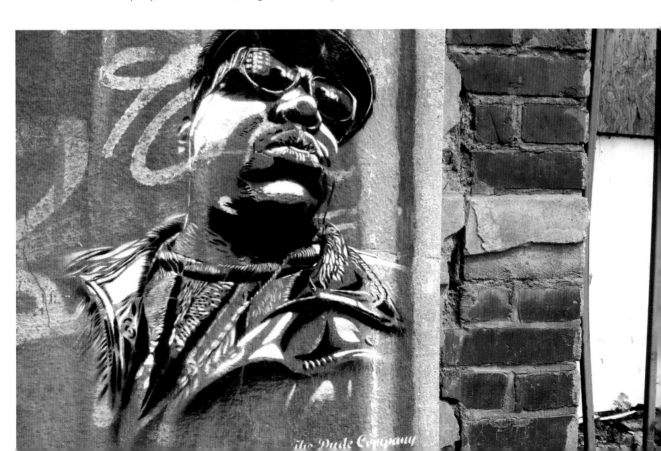

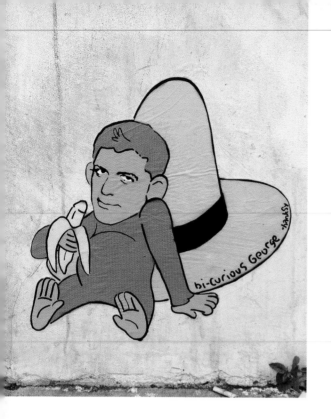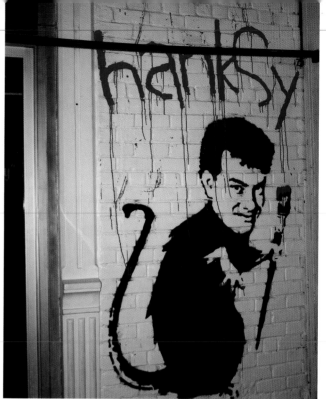

Above left: Hanksy, Bi-curious George (George Clooney), Los Angeles, California, USA, 2013.
Above right: Hanksy, Original Hanksy rat (Tom Hanks), New York, USA, 2012.
Right: Pegasus, Marilyn Monroe, London, England, 2013.
Below: Banksy, London, England, 2007. © *Sophie Duval / EMPICS / PA Images*

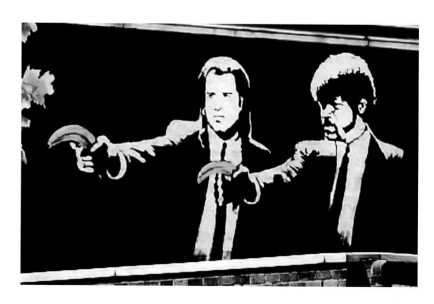

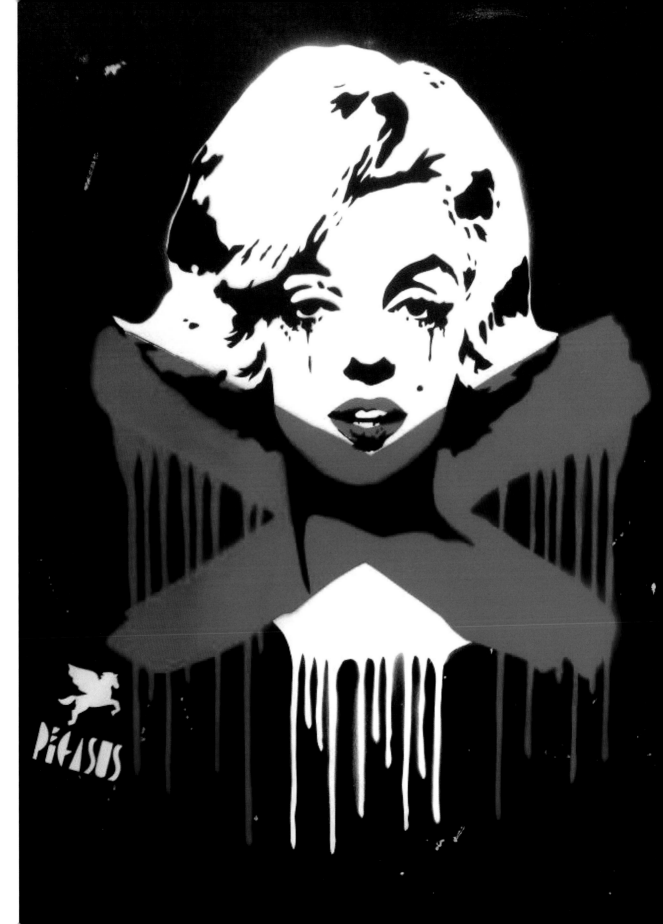

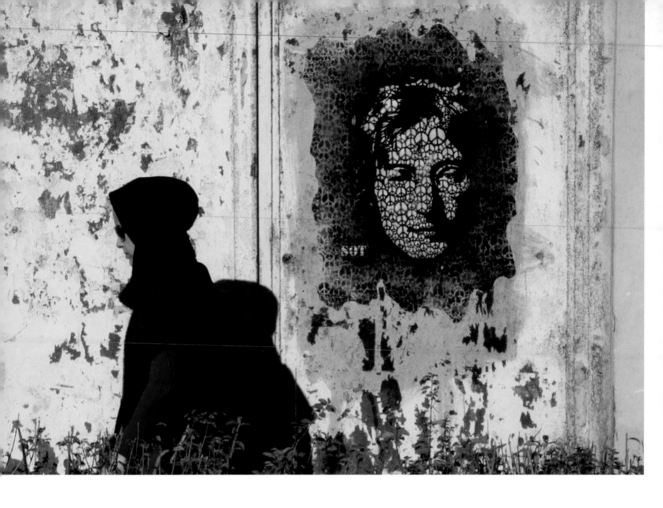

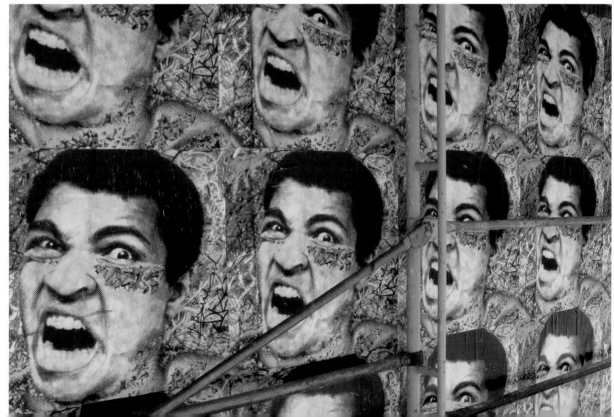

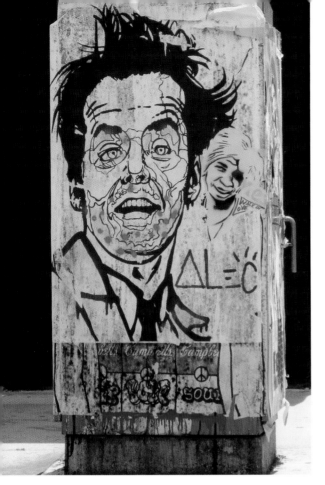

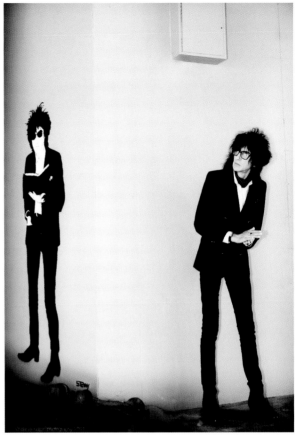

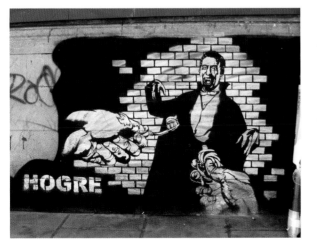

Opposite
Above: Icy and Sot, John Lennon, Tehran, Iran, 2010.
Below: Mr Brainwash, Ali, Los Angeles, California, USA, 2011. Photo by KET

Above Left: Alec Monopoly, Jack Nicholson, Los Angeles, California, USA, 2011. Photo by KET
Above Right: Stewy, John Cooper Clarke, London, England, 2011. Photo by Daniel Halpin
Left: Hogre, When in Bristol, London, England, 2013.

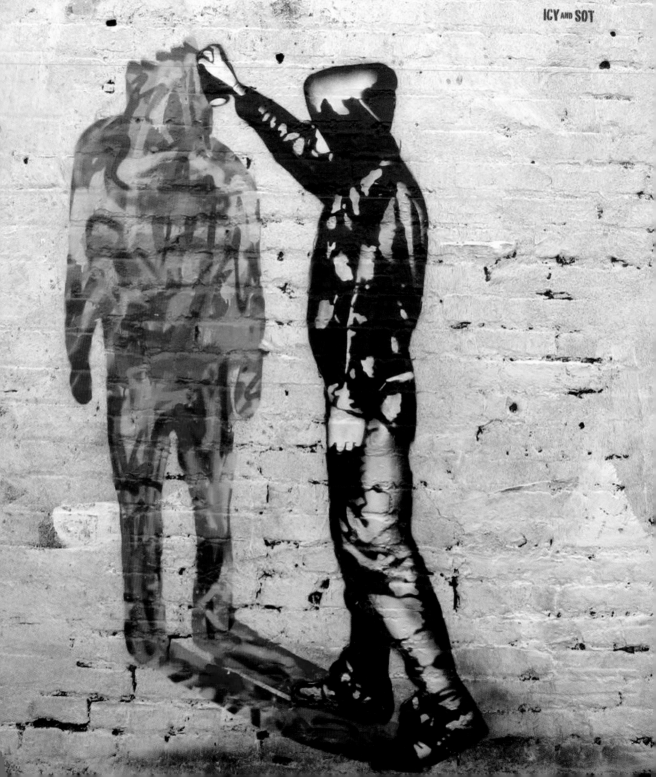

The hustle and bustle of city living can weigh heavy on people who are caught in the business of city life. Artists like Banksy, Tona, Zuk Club, and others featured here work in the streets to bring levity and humour in order to break through to the members of their community and the cities they travel to. For them it is important to contribute art in a way that brightens the day for those lucky enough to look at the wall on their way to their next appointment.

Left: Icy and Sot, Los Angeles,
California, USA, 2012.

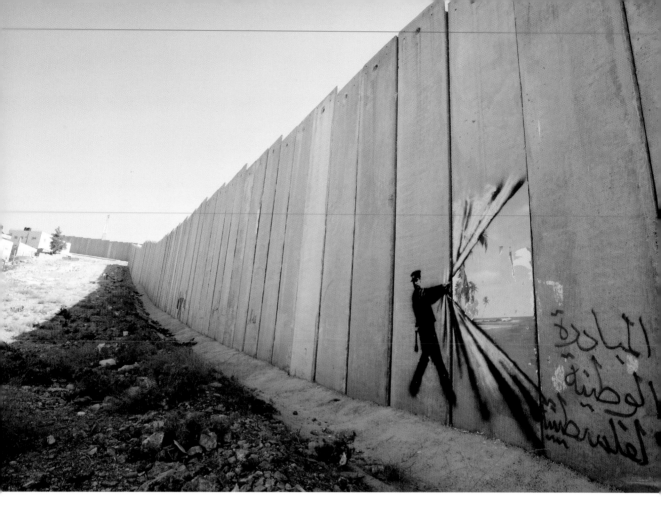

'I have always loved to draw. I think this is my main motivation.'

ZUK CLUB ART GROUP

Above: Banksy, West Bank, Israel, 2005. ©
Marco di Lauro / Getty Images
Above right: Banksy, New York, USA, 2013

Opposite
Above: P183, Moscow, Russia, 2009.
Below: Zuk Club, Dwarfs at Fabrica,
Fabrica Project, Moscow, Russia, 2012.

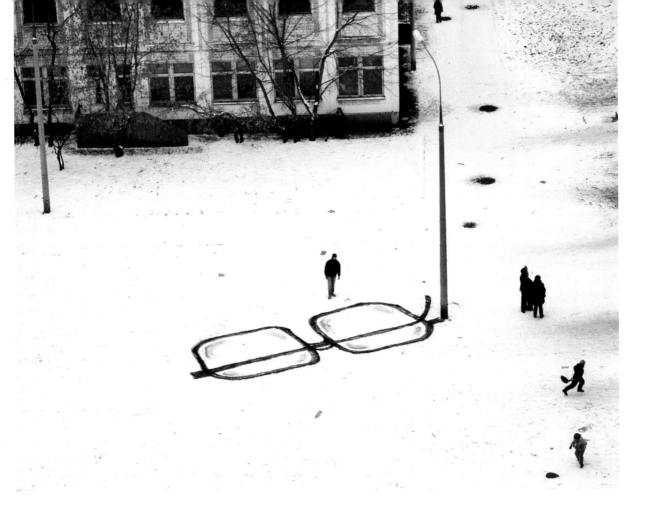

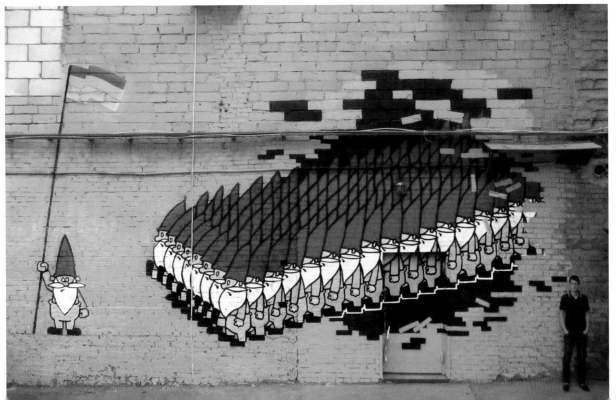

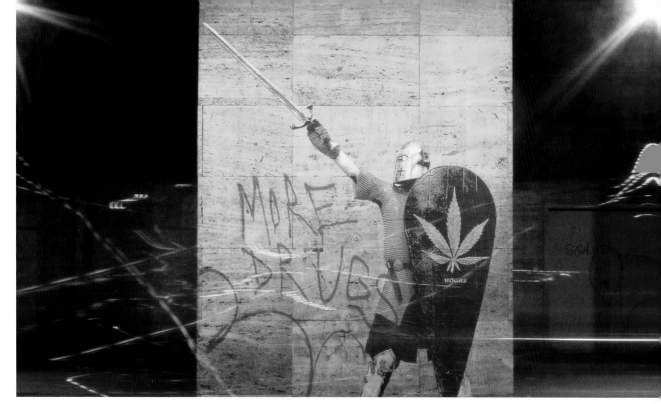

Left: Canvaz, www.canvaz.com, Dublin, Ireland, 2013.
Above: Hogre, Rome, Italy, 2012.
Below: Dede, Tel Aviv, Israel, 2010. Photo by Milli Katz

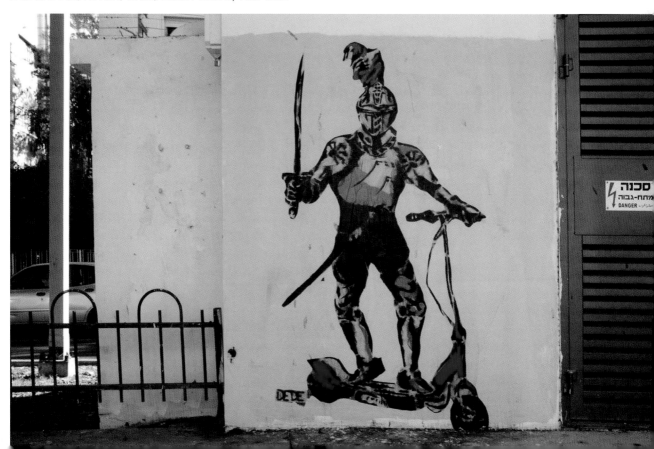

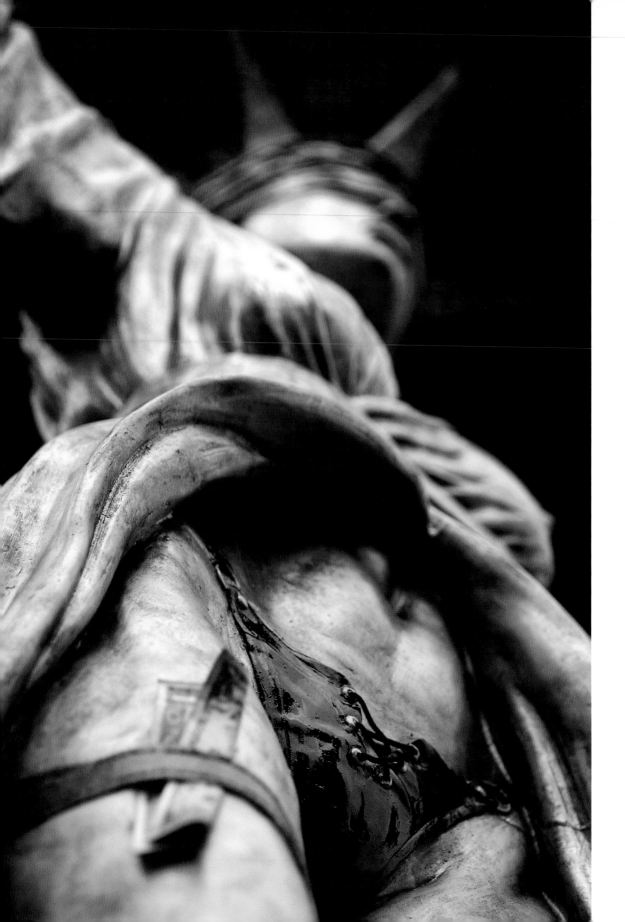

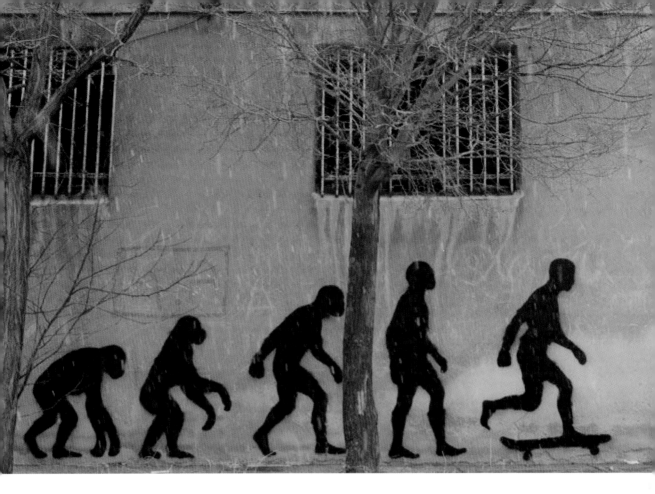

'We love painting in the streets and are always trying to send a message in our pieces about the crazy things that are happening around us in the world or the things that we have experienced. The themes are mostly about human rights, social issues, child labour, and peace and love.'

ICY AND SOT

Left: Banksy, London, England, UK, 2004.
© *Bruno Vincent / Getty Images*
Above: Icy and Sot, Tabriz, Iran, 2011.

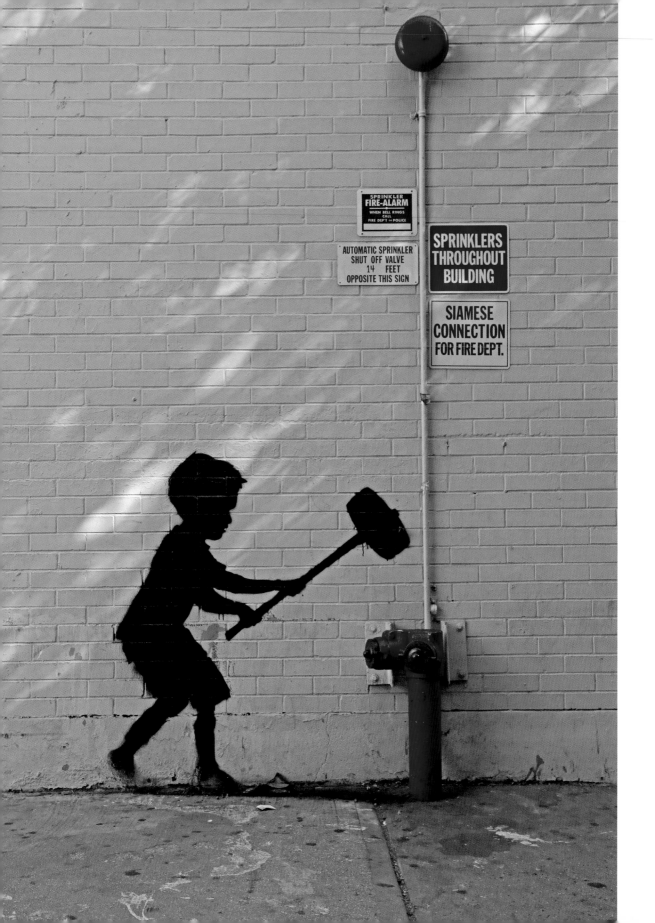

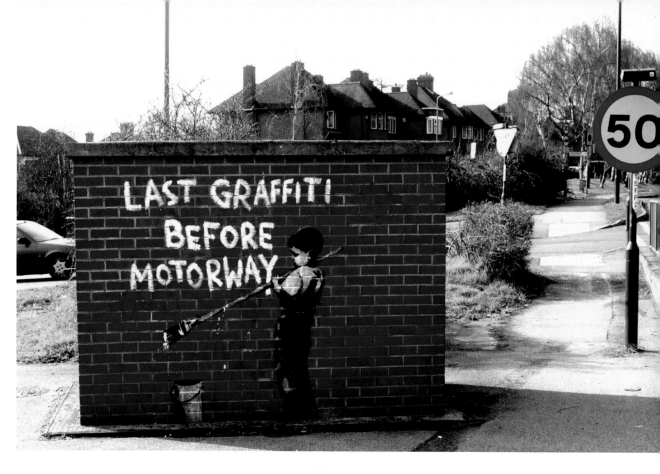

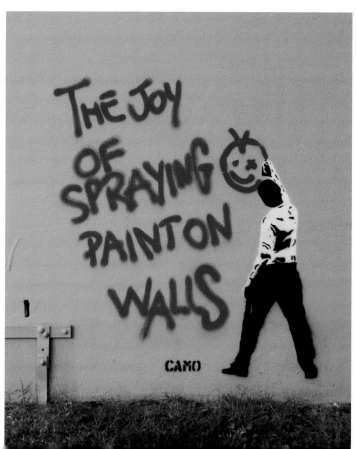

'There just needs to be more colour in the streets; from tags to large-scale murals and everything in between.'

CAMO

Opposite: Banksy, New York, USA, 2013.

Above: Banksy, London, England, 2009.
© *REX / Stuart Clarke*
Left: Camo, Botany, NSW, Australia, 2012.

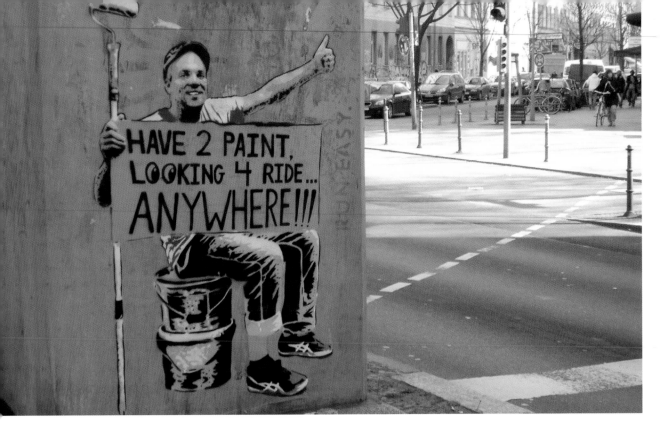

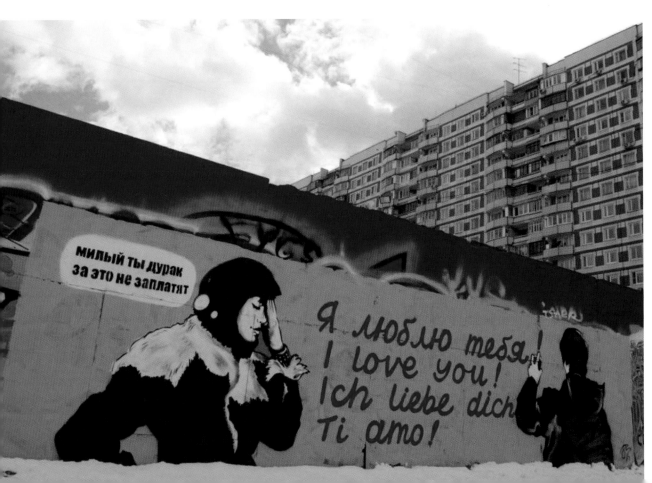

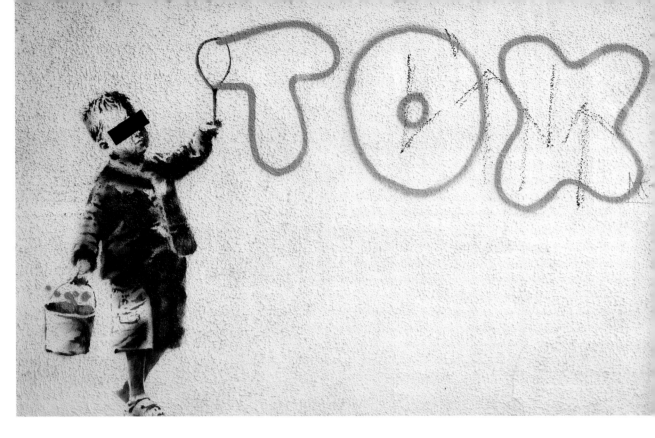

Above left: Above, Berlin, Germany,
2012. Photo by Julia Tulke
Left: P183, Moscow, Russia, 2011.
Above: Banksy, London, England, 2011.
© *Jim Dyson / Getty Images*

'You have to appreciate him
[Banksy] for getting so well known
for what he does, for his style
and smart concepts. No matter if
you like his work or not one must
respect the amount of work, fresh
images, and all the movement of
artists are looking up to him. He
was one of my influences to go
painting in the streets…'

CAMO

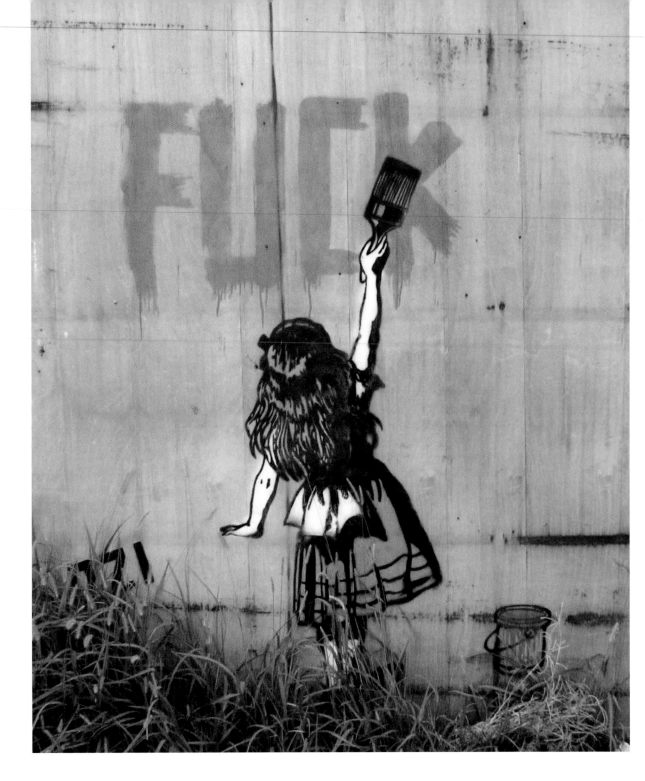

Above: Ozi, São Paulo, Brazil, 2012.

Opposite
Above: Unknown artist, Brooklyn, New York, USA, 2012.
Photo by KET
Below: Ben Eine, Vandals, Miami, Florida, USA, 2011.

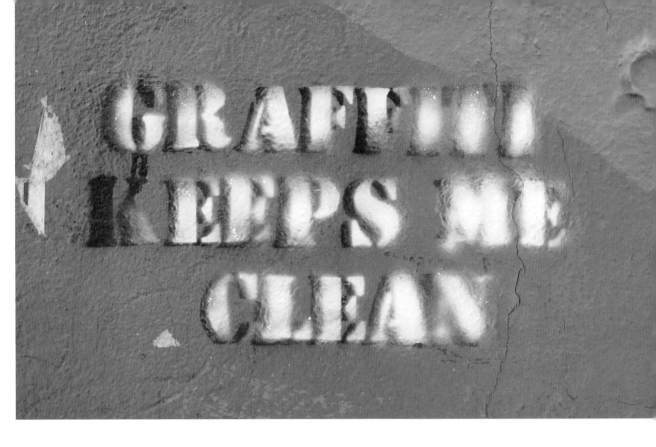

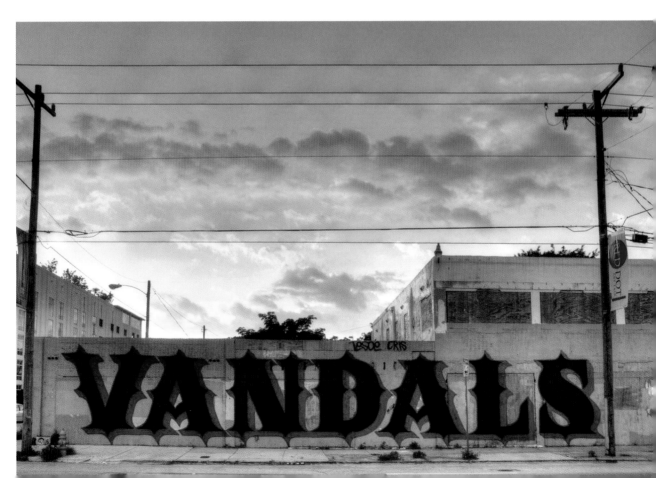

Below: Common Cents, Los Angeles, California, USA, 2012.
Right: Banksy, New York, NY, USA, 2008. © *REX / Sipa Press*

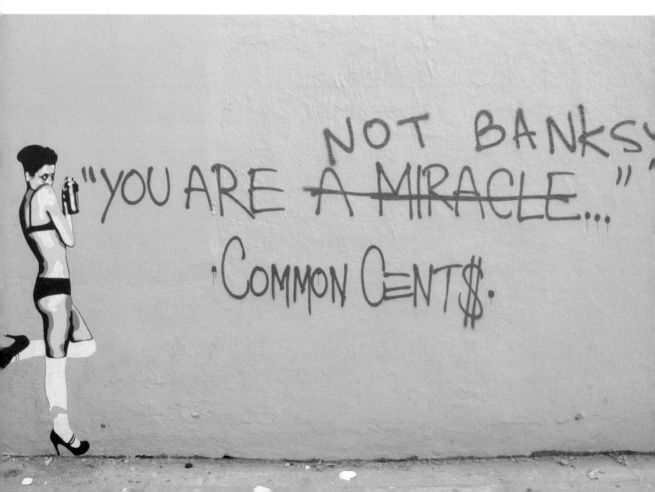

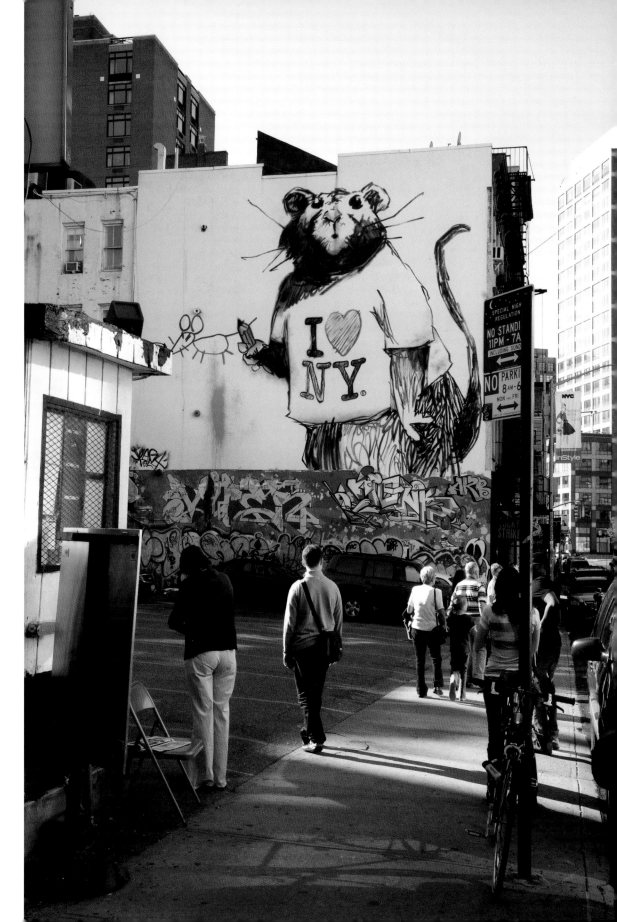

A BLANK PAGE
JUST SITS BEFORE
ME & STARES
IN COMPARISON
MY MARRIAGE
WITH THIS MARKER
IS IMPERATIVE
I STARE AT IT
& FIND MYSELF
STENCILING
THIS NARRATIVE
& PASTING IT
IN PLACE LIKE THE
TRAITS THAT
I INHERITED

- JERM IX

'The poetry scrolls consist of fragments of my poems and songs stenciled onto rolls of paper with permanent markers, one letter at a time. The poems are torn off of the roll and pasted up in the streets. The scrolls are bar none the most open and honest form of street art that I have put up. I open my heart and let it bleed out onto these pages. The scrolls primarily focus on my own internal struggles, sharing my deepest secrets and fears, and addressing and battling my inner demons. As far as growth and self improvement are concerned, the scrolls are the most important thing that I have ever done, equal to writing and recording the songs from my debut album "Jerm Warfare", that many of these scrolls were either sourced from, or inspired me to write.'

JERM IX

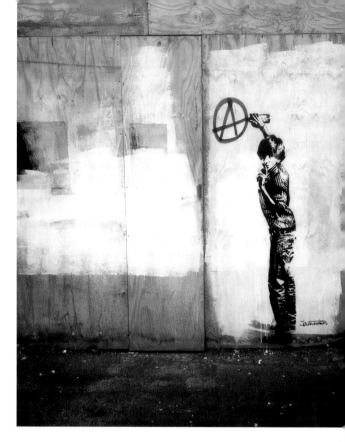

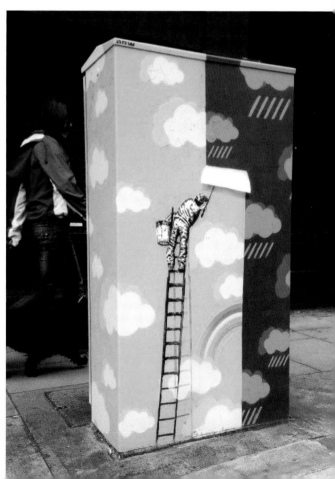

Left: Jerm IX, A Blank Page, Vancouver, BC, Canada, 2010.
Above right: The Dotmasters, London, England, 2012.
Right: ADW, I'll Paint Rainbows All Over Your Blues, Dublin, Ireland, 2013.

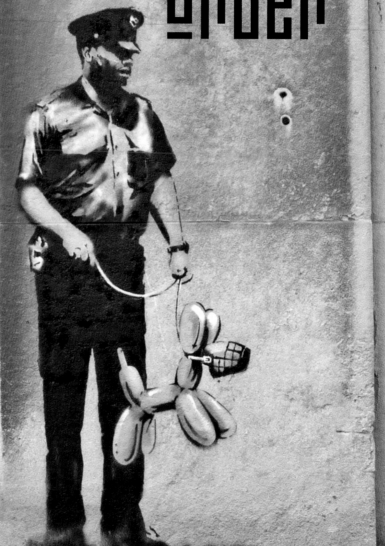

law and order

A favourite target for many street artists is the police and other authority figures. It goes without saying that the two groups are diametrically opposed, with police and government normally targeting street artists for arrest. Street artists around the world, including Banksy, have specifically created images poking fun at the police for targeting such minor crimes as graffiti and street art. Banksy and others have also taken it a step further by creating images that illustrate the injustice and harm that civilians experience at the hands of authorities. These artistic interventions are particularly bold in cities like New York City and Cairo where authorities in the past and present are known to be brutal and have murdered artists (Michael Stewart in New York and Ahmed Basiony in Cairo).

Left: Banksy, Toronto, Canada, 2010.
Photo by KET

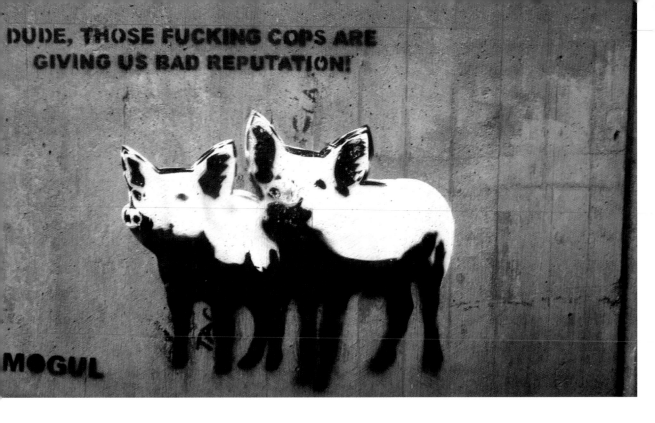

Above: Mogul, Stockholm, Sweden, 2012. Photo by Thomas Olsson
Below: Banksy, Turf War exhibition, London, England, 2003. © *Ian West / PA Images*

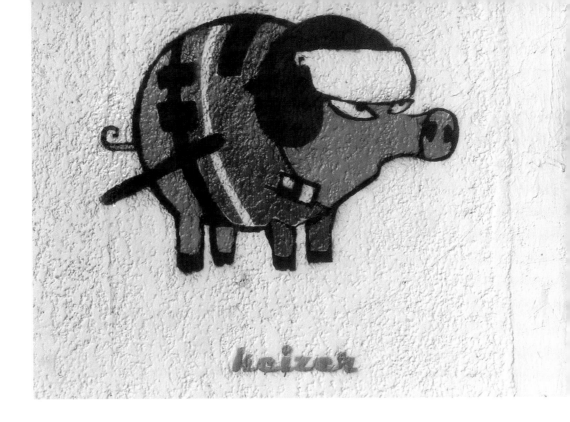

'[I communicate that] we are getting fucked around and lied to every day by totalitarian governments and outdated religious institutions, all while making people smile and stop to Instagram it.'

E.L.K.

Above: Keizer, SCAF Pig, Ministry of Agriculture, Dokki, Giza, Egypt, 2011.
Right: E.L.K, Melbourne, Australia, 2011.

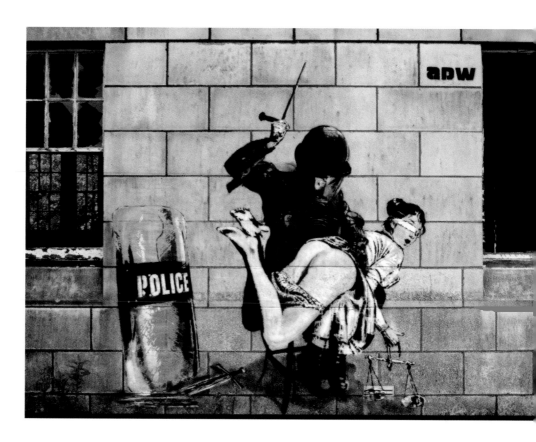

Above: ADW, There Is No Justice,
There's Just Us, Dublin, Ireland, 2013.
Right: Banksy, 'Barely Legal'
exhibition, Los Angeles, CA, USA,
2006. © *REX / Sipa Press*

'In a society where it is easier
to label and pigeon hole
people, our individuality and
uniqueness is whittled down
to being just a statistic.'

ADW

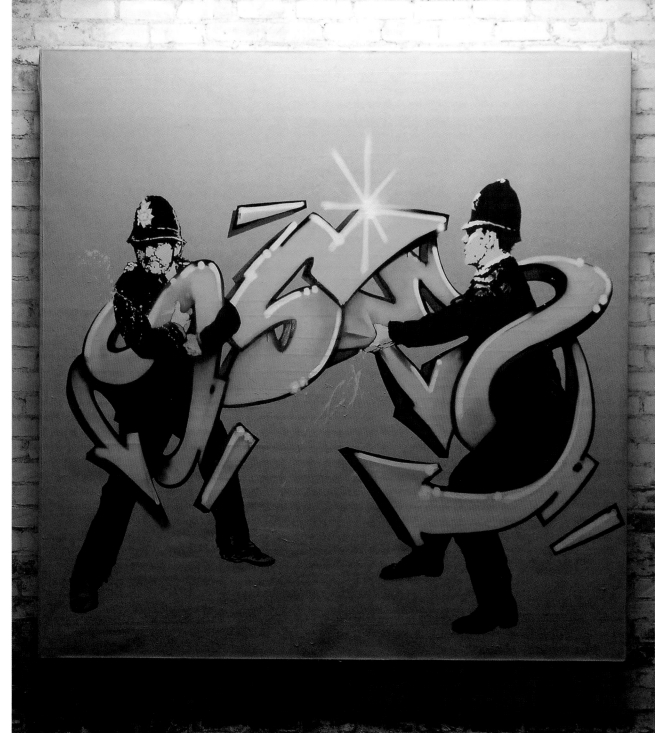

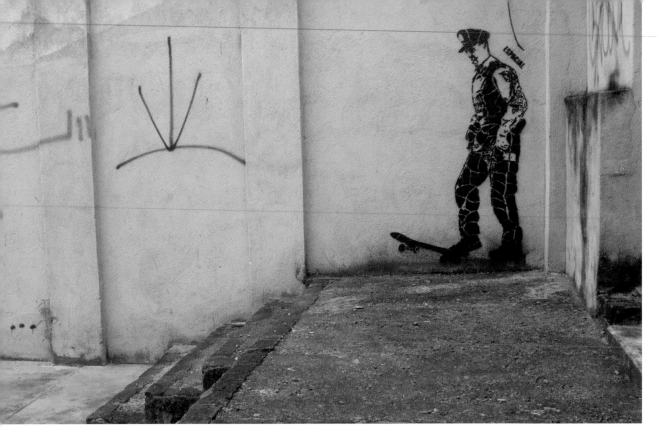

Above and below: Matias Espacial Picón, Rua 5, São Paulo, Brazil, 2012.
Right: Banksy, Brighton, England, 2005. © *Roger Bamber / Alamy*

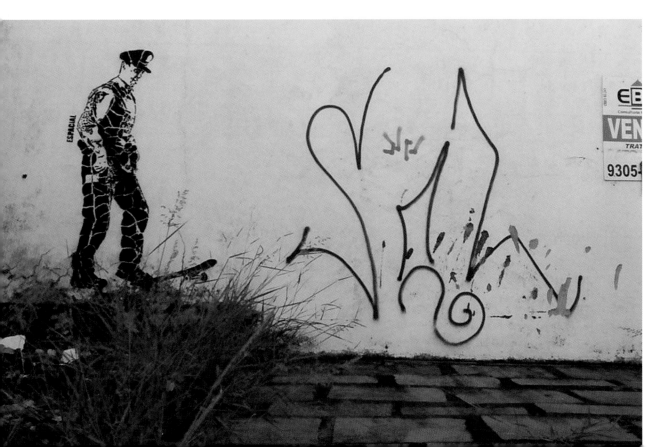

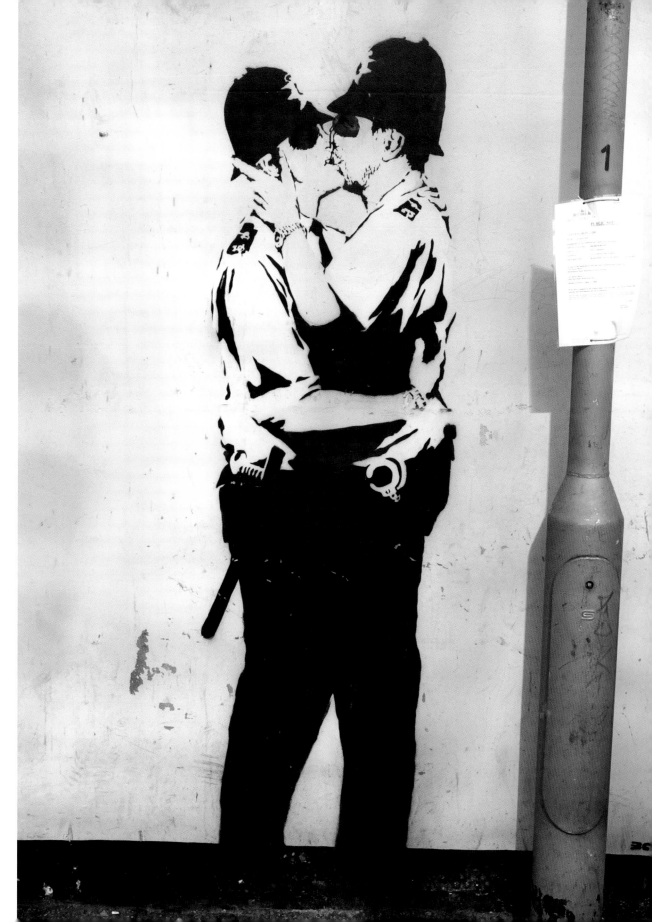

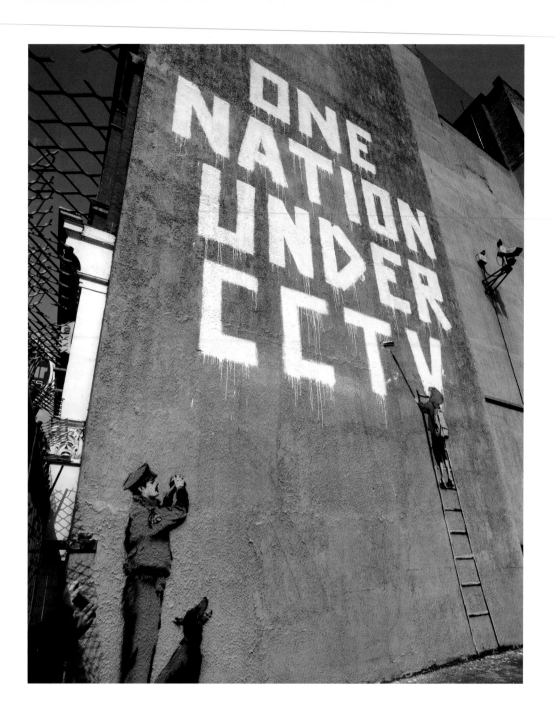

Above: Banksy, London, England, 2008. © *Fiona Hanson / PA Images*
Right: Site of Banksy artwork painted over by Westminster Council, London, England, 2009. © *Mark Phillips / Alamy*

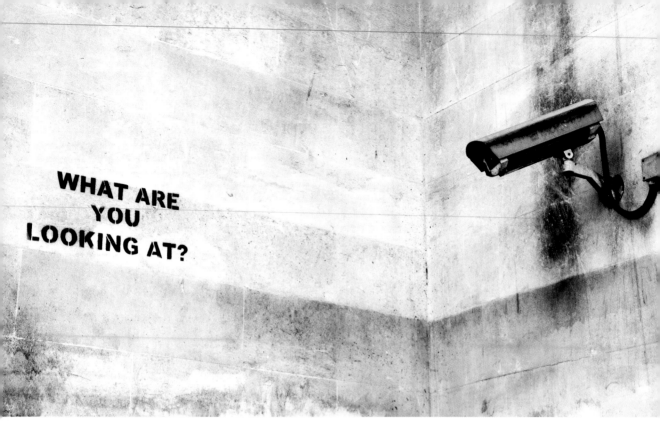

Above: Banksy, London, England, 2007.
© *Jeremy Reddington / Shutterstock*
Above right: Zabou, London, England, 2013.
Right: Sajjad Abbas, We can see you
(looking at the politicians in the green zone),
Baghdad, Iraq, 2013.

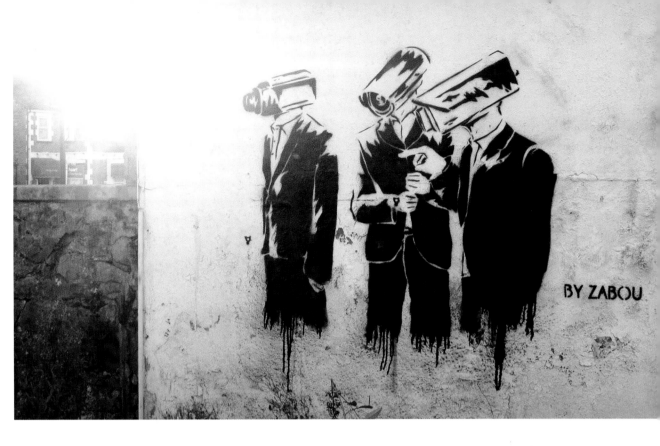

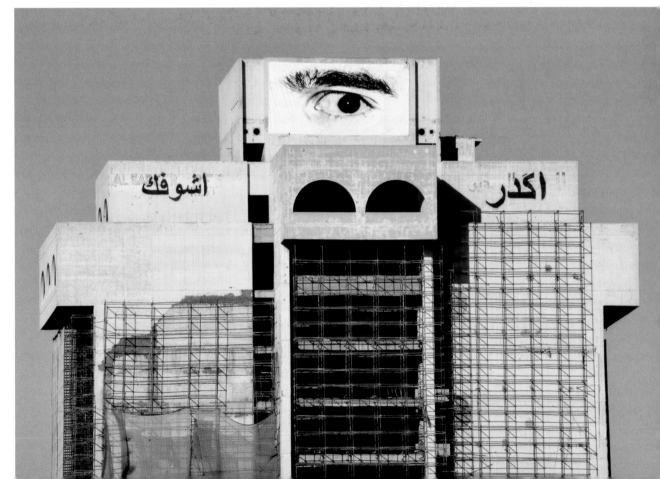

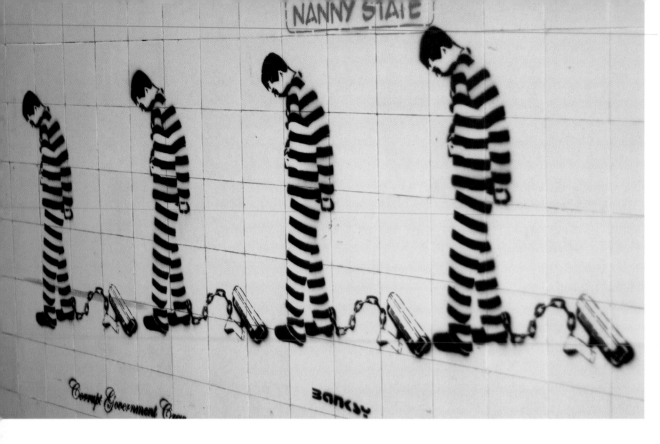

Above: Banksy, London, England, 2008. © *Sean Francis / Alamy*
Below: Dr D, GCHQ, London, England, 2010.

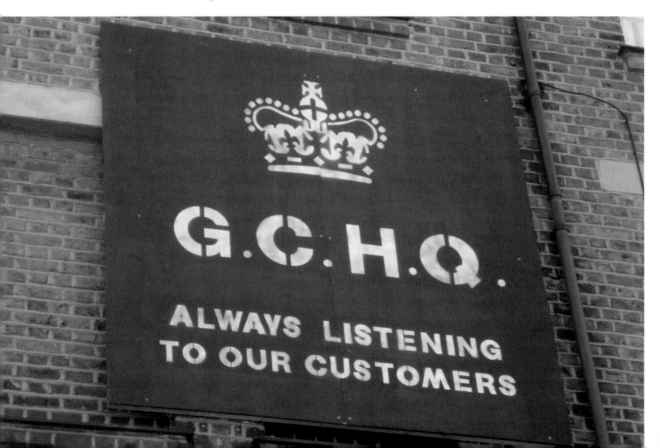

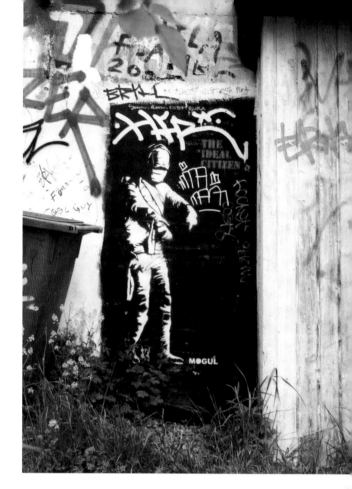

Right: Mogul, Stockholm, Sweden, 2012.
Below: Dr D, I'd Feel Safer If You Left Me Alone, London, England, 2010.

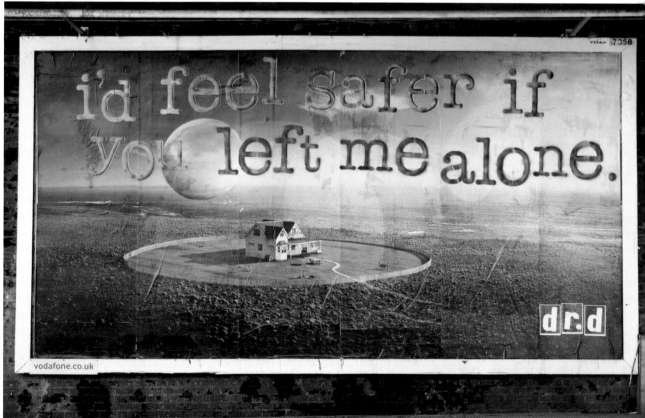

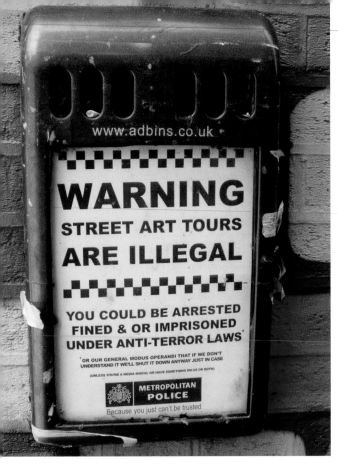

Left: Dr D, Warning, London, England, 2012.
Below: EPS, Power to the People, White Wall project, Beirut, Lebanon, 2012.

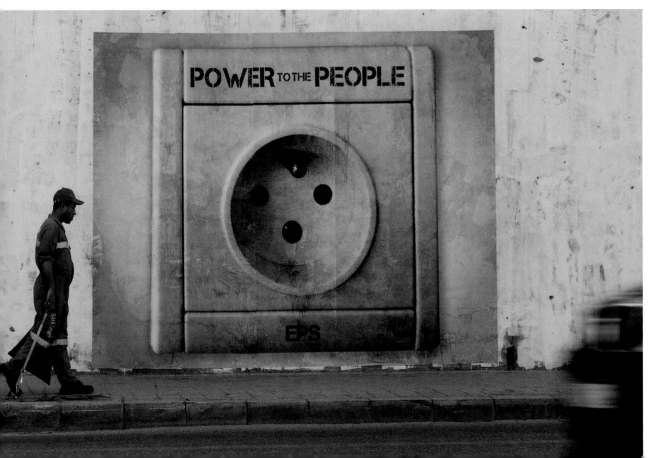

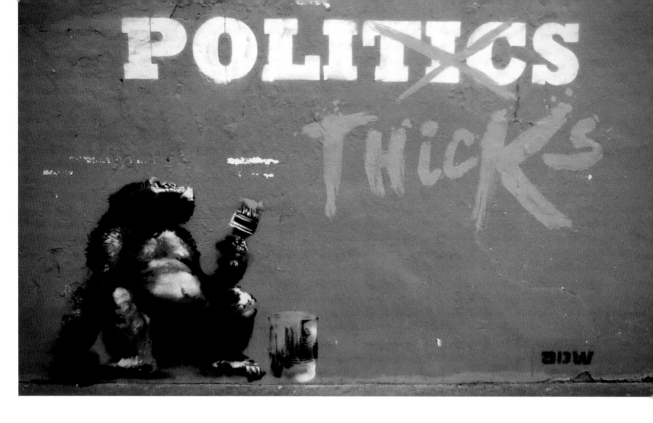

Above: ADW, poliTHICKS, Dublin, Ireland, 2013.
Below: Mogul, Stockholm, Sweden, 2013.

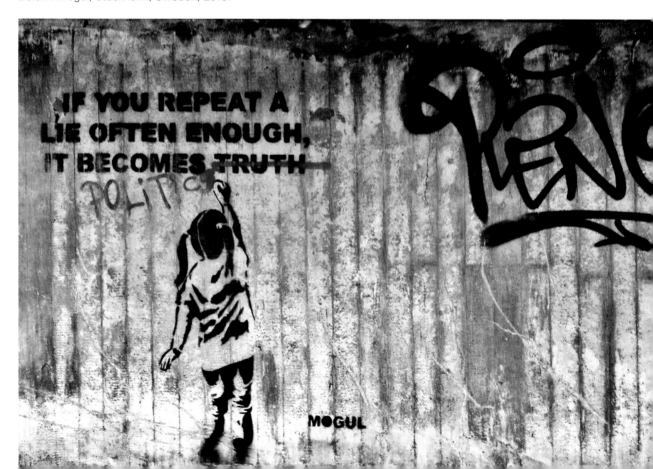

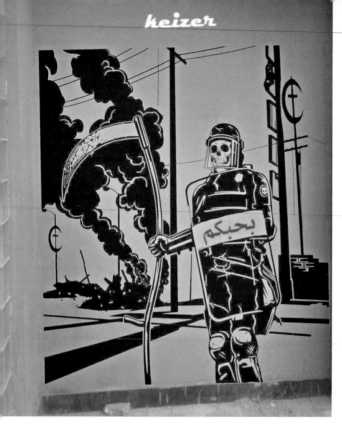

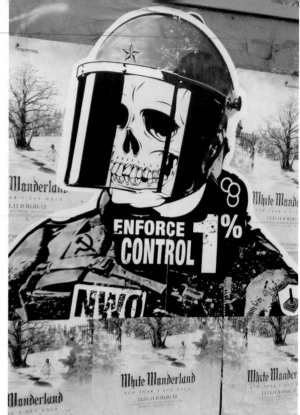

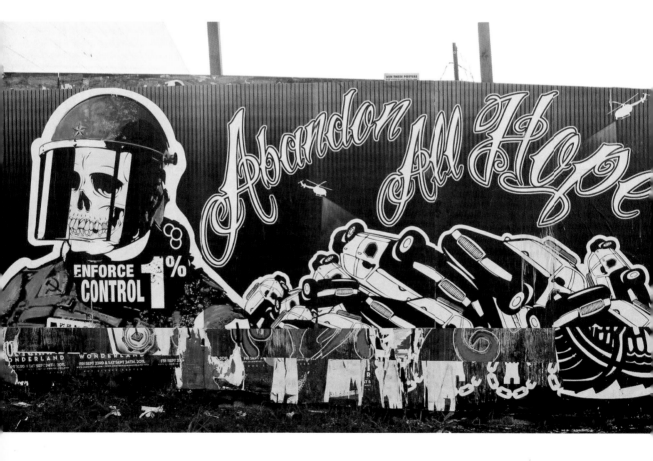

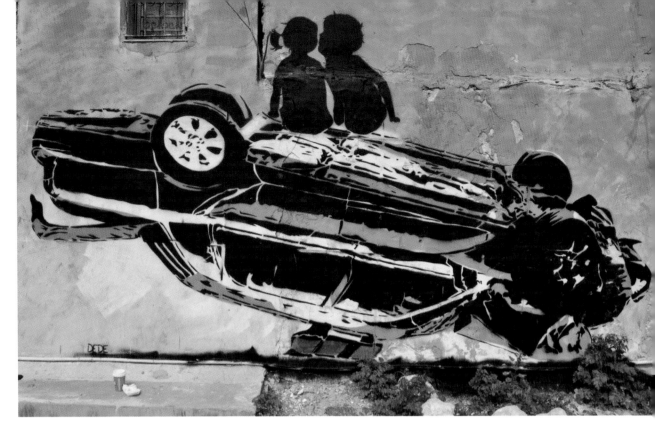

'During the Occupy movement, a lot of street art was about the 99%. I chose to point a finger at the 1% and their enforcers of tyranny . . . the riot police.'

DESTROY ALL DESIGN

Above: Dede, Tel Aviv, Israel, 2011.
Photo by Milli Katz

Opposite
Above left: Keizer, Maspero, Egypt, 2012.
Above right: Destroy All Design, Los Angeles, California, USA, 2012.
Below: Destroy All Design, Los Angeles, California, USA, 2012.

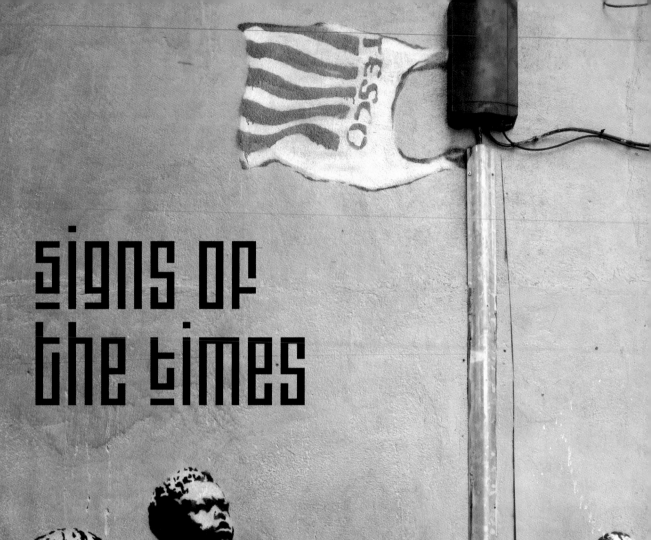
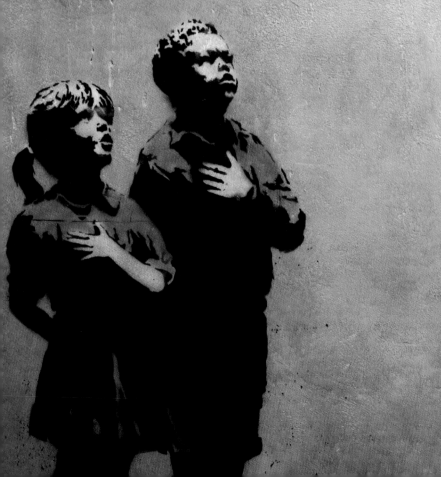

signs of
the times

Street artists around the globe cast a light on the problems that people are experiencing today. They are modern age visual *griots* pointing out the struggle that exists internationally with corporate corruption and greed, staggering unemployment, injustices against the poor and working class, and a growing class divide that is leaving many people by the wayside. Street artists magnify the sentiment of a working class that is struggling to make ends meet and the many who have hope for a better world. What better place to reach people but on the streets? In the words of Colombian artist Toxicómano Callejero, the public spaces, the streets, are the ideal spaces to communicate everything we believe, people pay attention to what they see in the streets and automatically believe that it is important and valid.

Left: Banksy, Islington, London, England, 2008. © *Chris Dorney / Shutterstock*

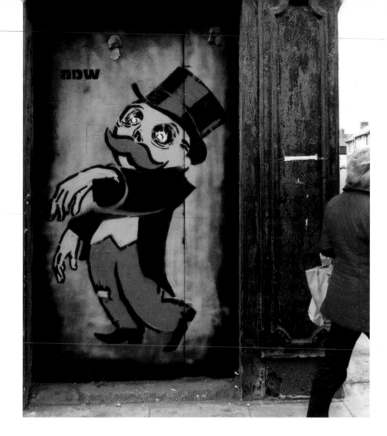

Right: ADW, Infected, Dublin, Ireland, 2012.
Below: Banksy, Occupy anti-banking
demonstration, London, UK, 2011.
© *yampi / Shutterstock*

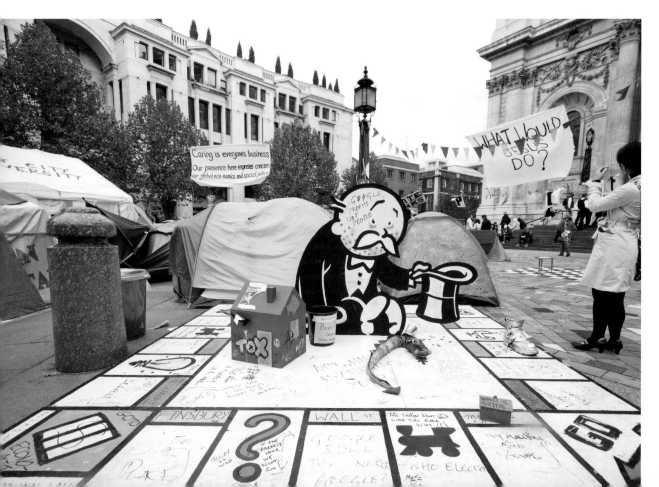

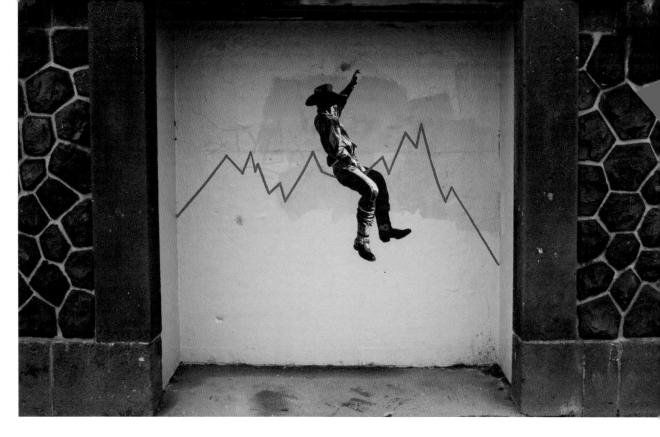

Above: Decycle, Rodeo Rider, Düsseldorf, Germany, 2013.
Below left: Canvaz www.canvaz.com, Dublin, Ireland, 2013.
Below right: Hogre, Rome, Italy, 2012.

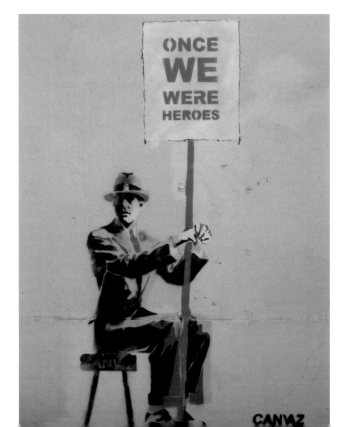

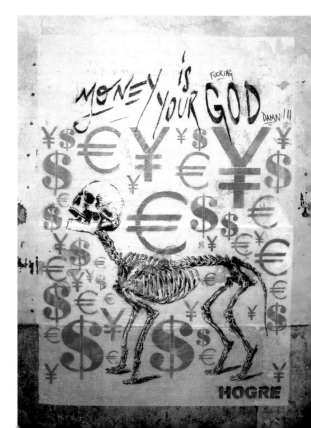

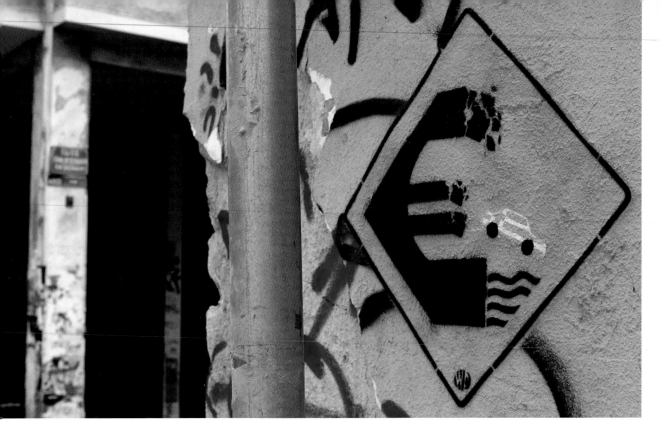

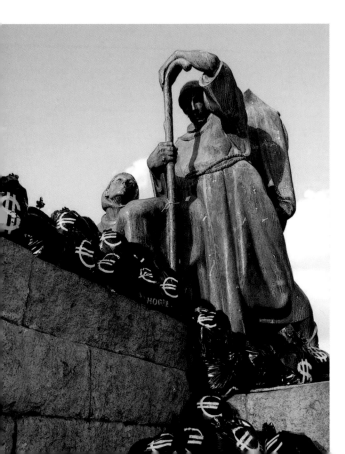

'I started painting outside in 2000 in Bali (my origin is from Bali, Indonesia). In 2006 I moved to Greece and from that time I paint in the streets of Athens. As for inspiration, I could say that lifestyle and social phenomena such as consumerism, unemployment, injustice etc. inspire me most.'

WD (WILD DRAWING)

Above: WD (Wild Drawing), Athens, Greece, 2011.
Left: Hogre, Rome, Italy, 2012

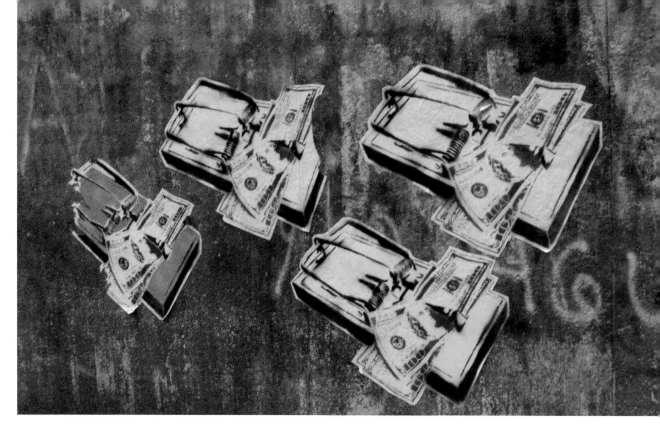

Above: BS.AS.Stencil, Dollar Tramp, Buenos Aires, Argentina, 2012.
Below: T.Wat, Eat the Poor, London, England, 2010.

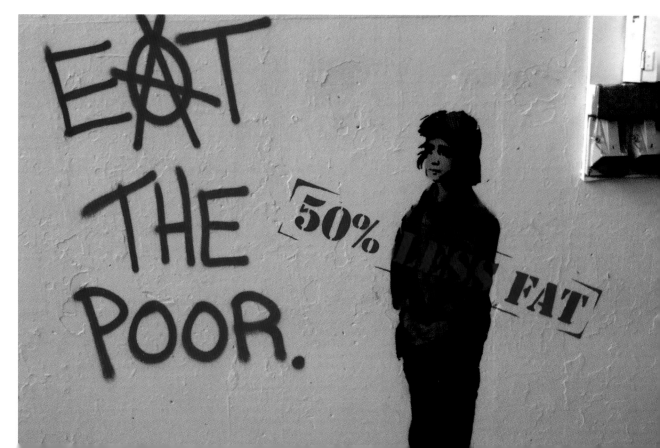

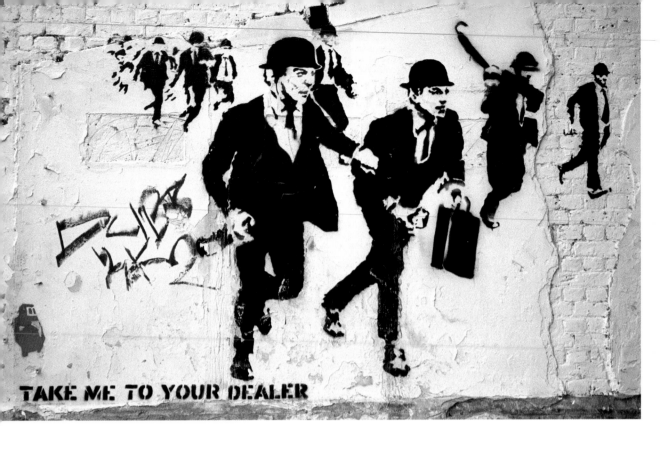

TAKE ME TO YOUR DEALER

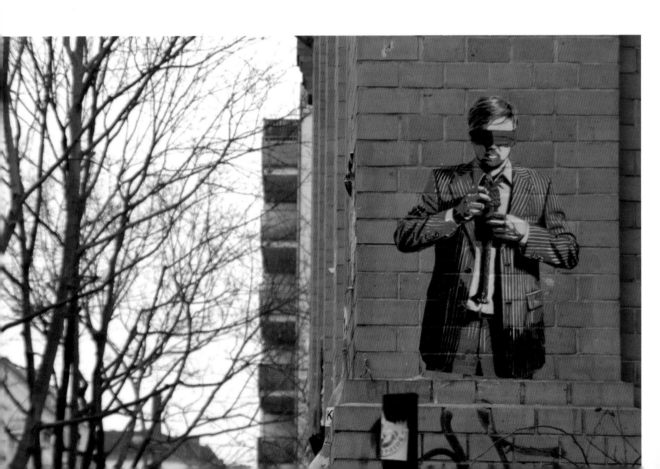

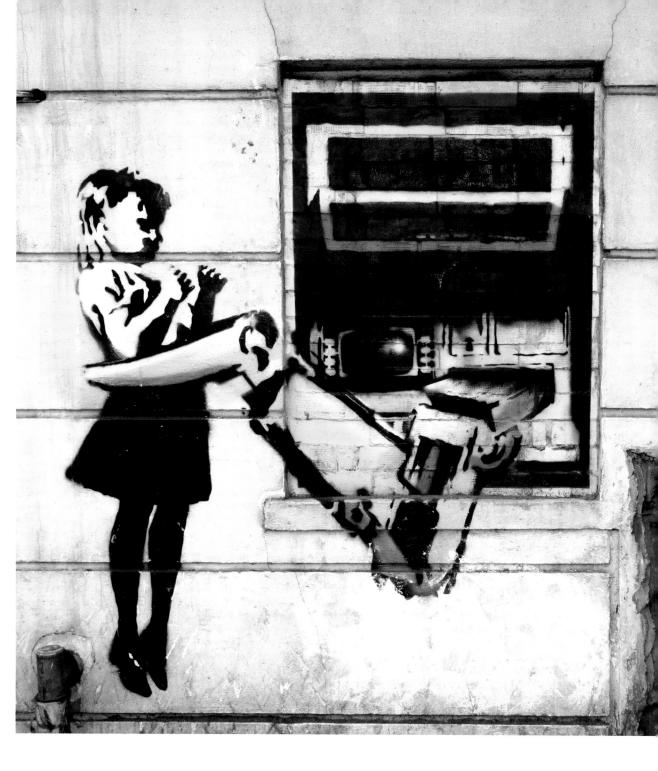

Above: Banksy, London, England, 2007. © *Chris Dorney / Shutterstock*
Opposite
Above: Banksy, London, England, 2000. © *Tom Stoddart / Getty Images*
Below: Decycle, Bochum, Germany, 2012.

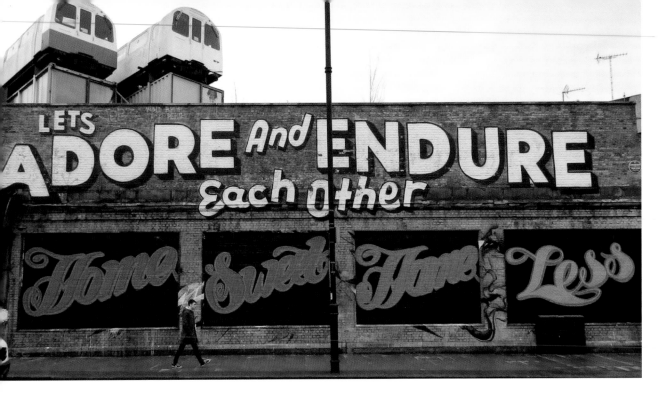

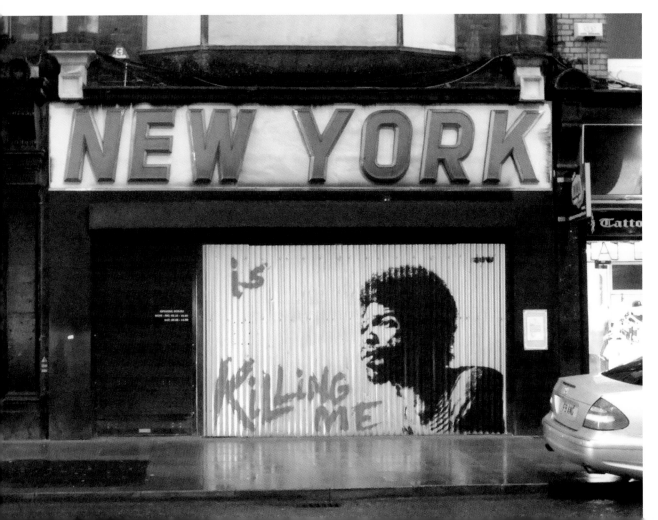

Left: Ben Eine, Homeless,
London, England, 2012.
Photo by Myriam Preston
Below left: ADW, Is Killing Me,
Dublin, Ireland, 2012.
Below: Icy and Sot, Brooklyn,
New York, USA, 2012.

'Stencils are a good way
of getting a clear message
across and are easy to
produce and spray…suppose
it was ease that first got
me hooked, of course you
complicate things over time,
more colours, more intricate
detail, but still it's the quick
application and speed that
make me still love and use
them.'

THE DOTMASTERS

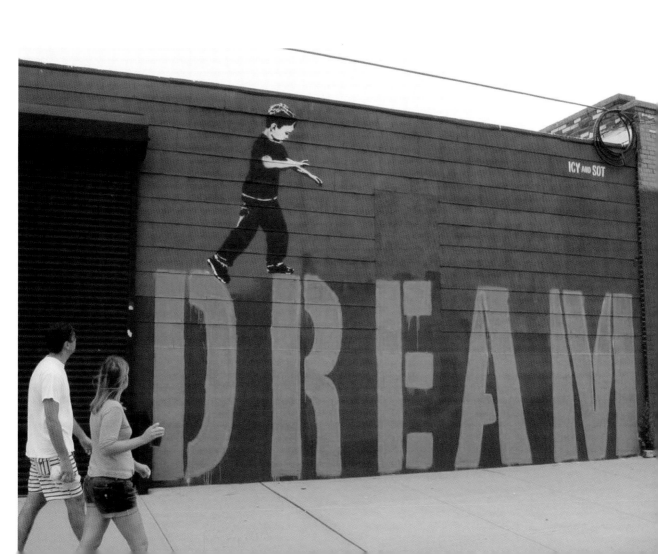

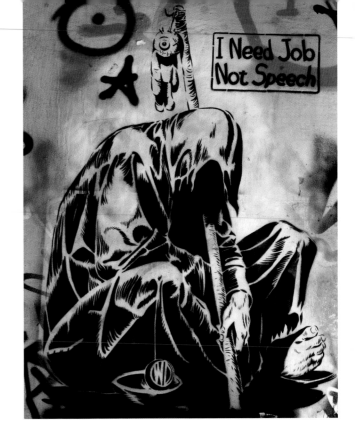

Right: WD (Wild Drawing),
Athens, Greece, 2013.
Below: Banksy, London Calling,
London, England, 2010. © *Jim
Dyson / Getty Image*s

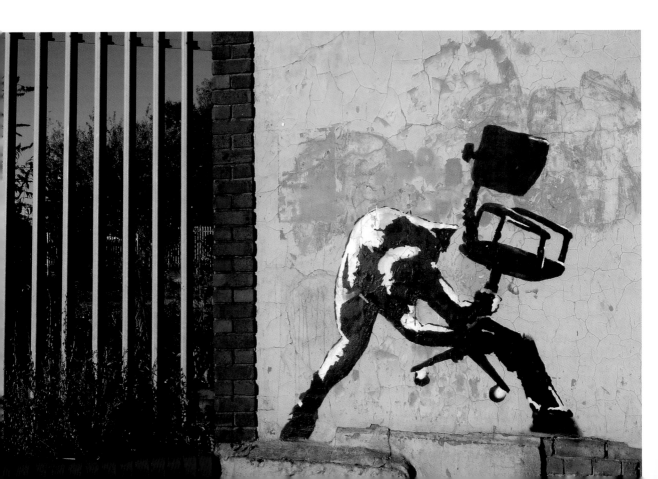

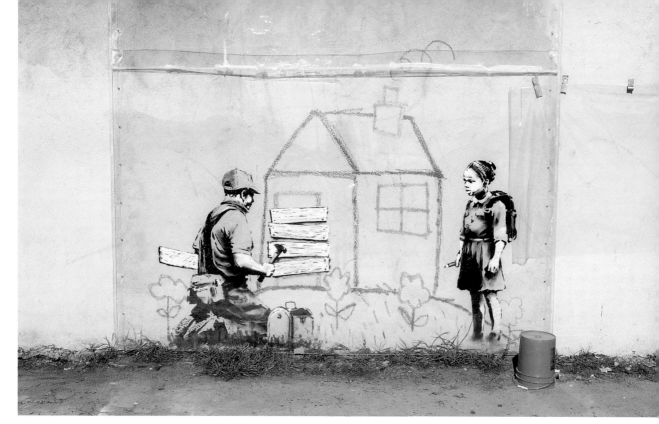

Above: Banksy, Crayon Foreclosure, Los Angeles, California, USA, 2011. © *Jason LaVeris / FilmMagic / Getty Images*
Below: WD (Wild Drawing), Athens, Greece, 2011.

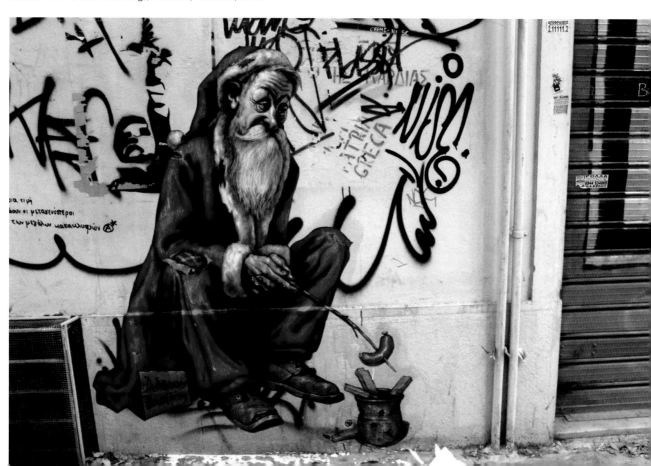

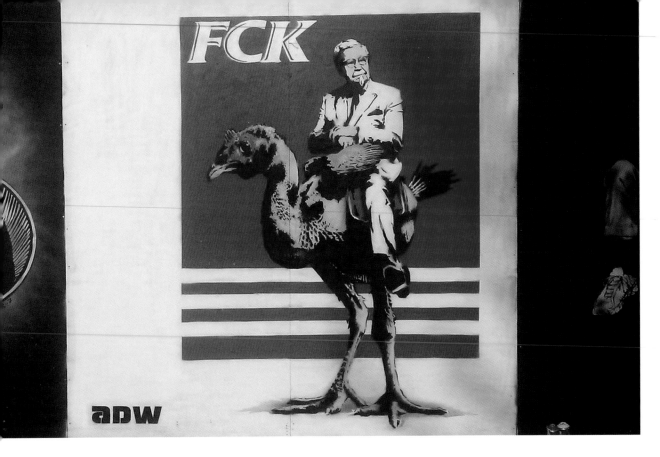

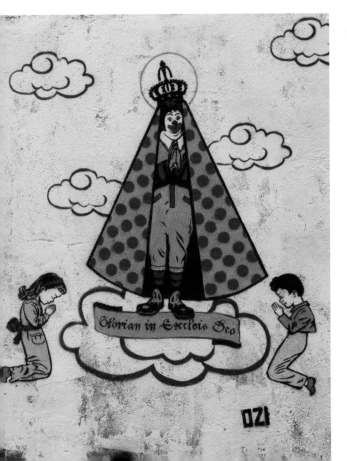

Above: ADW, Dublin, FCKd, 2011.
Left: Ozi, São Paulo, Brazil, 2012.
Right: T.Wat, Hackney Road, London,
England, 2010.

'Nowadays, my city is
swallowed by graffiti, and it
turns into São Paulo's second
skin, I see my city all tattooed...
and people are familiarized
with this tattooed skin.'

OZI

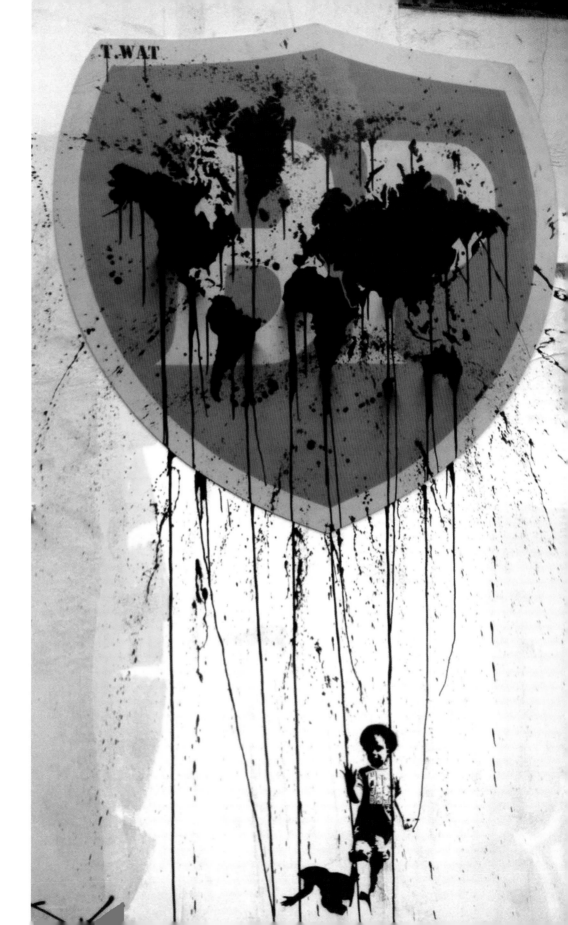

'I think of the role of a street artist is like having your own (pirate) radio channel. The idea, though, is not about precision of information (the truth). For me, the great potential of street art is about the exploration of a fantasy space incorporating the reality and human imagination.'

BBROTHER

Above: Banksy, London, UK, 2011.
© *Jim Dyson / Getty Images*
Left: The Dotmasters, Munich, Germany, 2012.

'All sorts of stuff makes me want to paint, wrong rights and generally add a little humour to our dull streets, It's often a puerile political thought and sometimes it's just cos I have a trashy mouth.'

THE DOTMASTERS

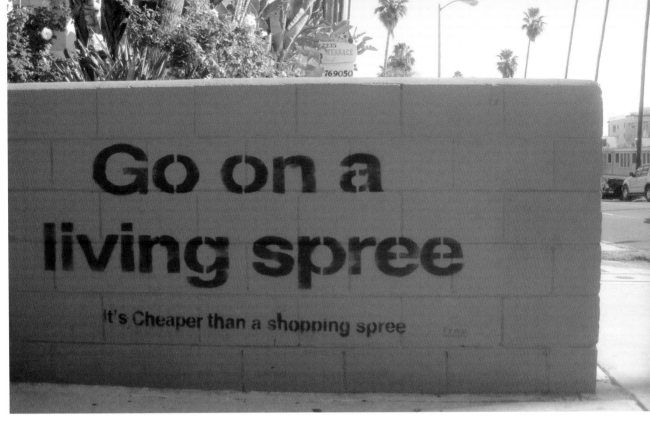

Above: Free Humanity, Los Angeles, California, USA, 2013.
Below: Banksy, London, England, 2011. © *Jim Dyson / Getty Images*

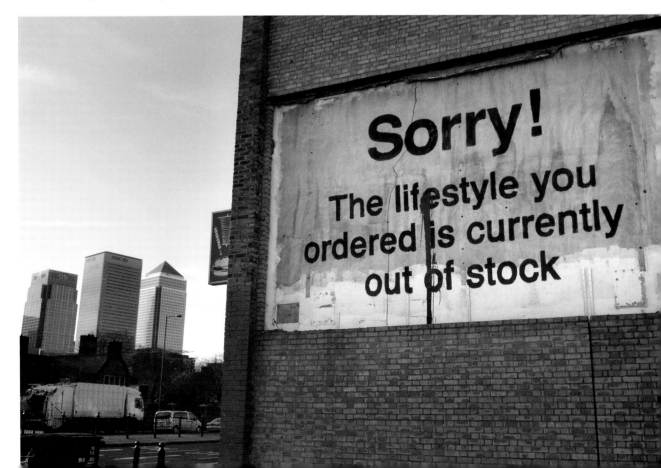

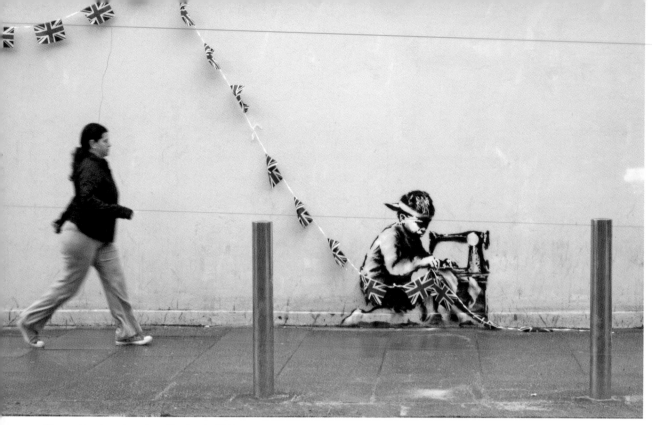

Above: Banksy, London, England, 2012.
Below: Bbrother, Cow, Taipei, Taiwan, 2009.
Right: ADW, Labelz are for Jars, Dublin, Ireland, 2012.

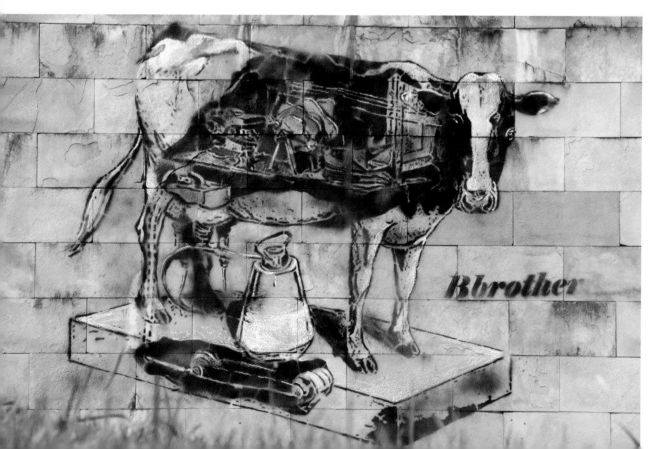

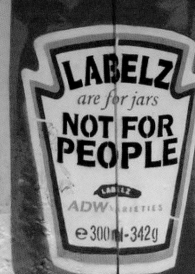

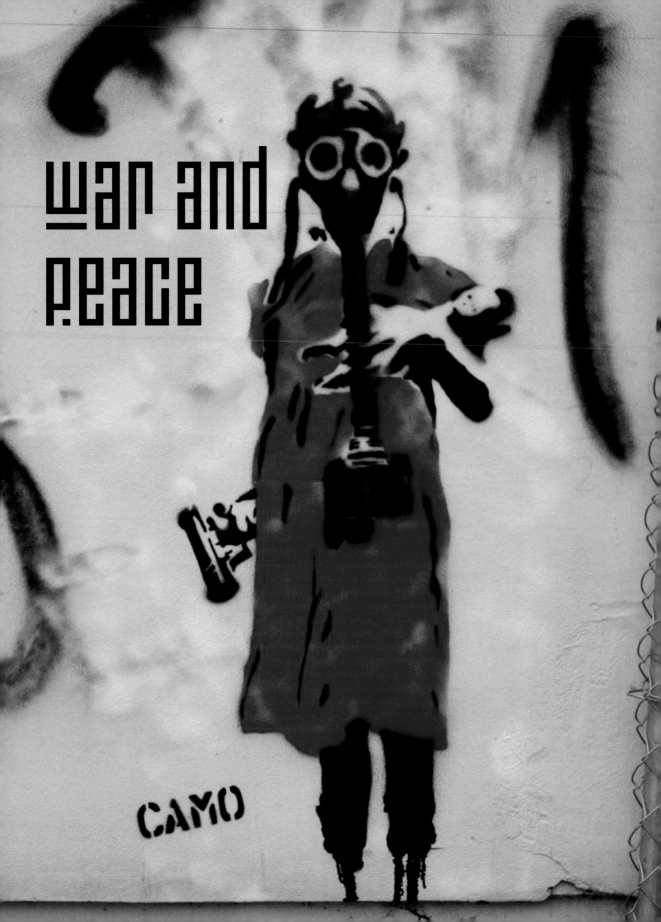

Across the planet governments wage war and people in conflict areas struggle to stay alive. There is a growing awareness and anti-war sentiment that is spreading worldwide. Many of us do not believe that war has to exist and are compelled to protest for peace. At rallies we channel our inner artist to create protest signs. Similarly, for centuries artists have been outspoken critics of war, injustice and corruption, even dying for their political beliefs, while many around the world are still being persecuted today.

In modern times war and warmongers have been called out by name by artists like the famous Robbie Conal with his street posters. However it has been artists like Banksy and Code FC who have turned the message on its head, creating arresting images of children interacting with warheads, soldiers rebelling against authority, or victims rising up against government oppression. By using images of civilians and soldiers in the streets, war is transformed from an abstract far-off event to one that all of us can relate to as individuals. We are painted into the picture. Many of the images that seem to ridicule war are a difficult reminder that in many of the cities in which these images exist we are so far removed that war seems like a bad joke – a caricature of the horror of war. Other artists depict people in gas masks, as if preparing for war and destruction.

The artists shown here are bold activists for a better world and their message is on the walls around us. Some, in countries like Egypt, Iraq, and Syria, are risking their lives to express their point of view.

Left: Camo, Alexandria, NSW, Australia, 2012.

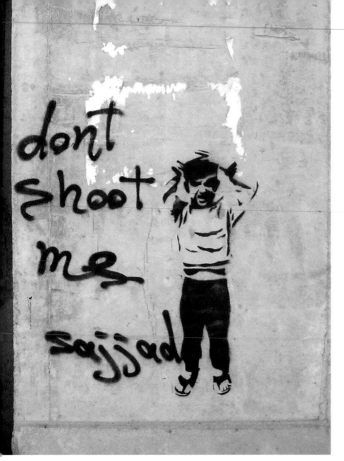

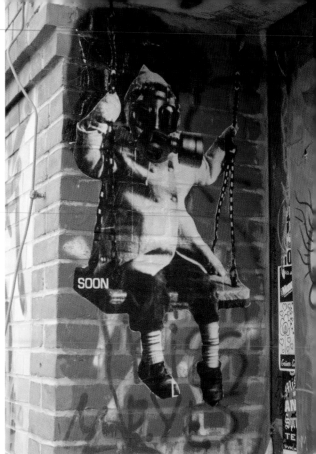

'I love painting more than anything. It gives me a voice and I would be lost without it.'

SOLUS

Above Left: Sajjad Abbas, Baghdad, Iraq, 2011.
Above Right: Soon, Berlin, Germany, 2013.

Opposite
Above: Solus, Dublin, Ireland, 2013.
Below: Alias, Hamburg, Germany, 2011.
Photo by Theo Bruns

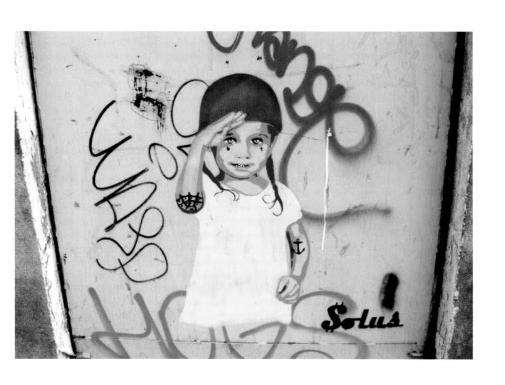

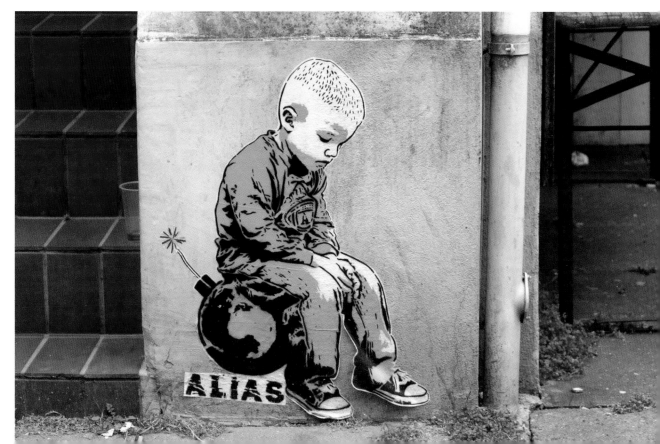

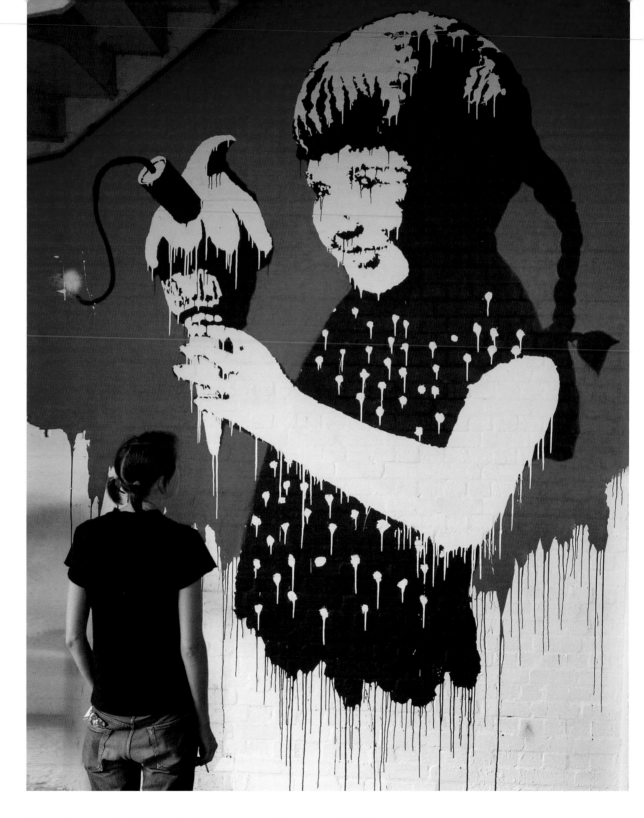

Above: Banksy, 'Turf War' exhibition, London, England, 2003. © *REX*

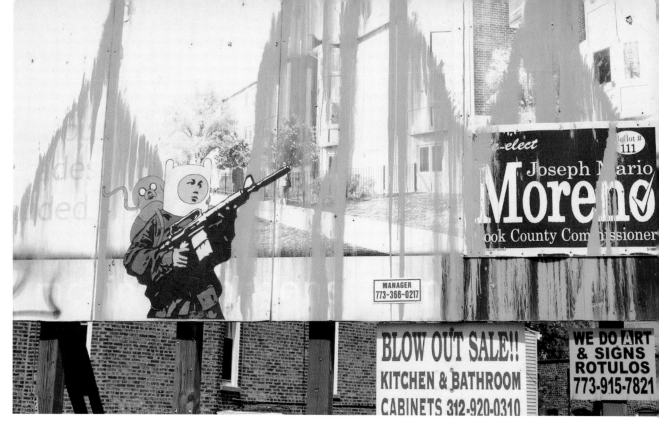

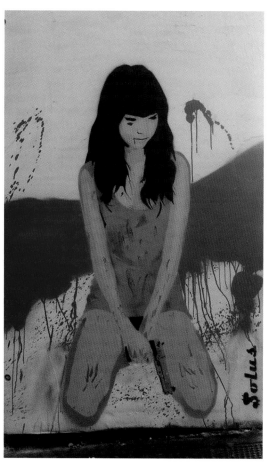

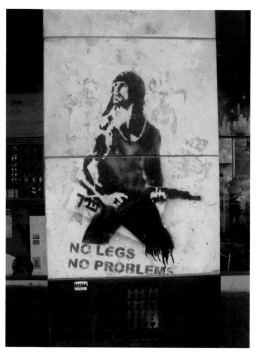

Top: Jay Jasso, Adventure Time, Chicago, Illinois, USA, 2013.
Above left: Solus, Dublin, Ireland, 2013. Photo by
David Johnson
Above right: Unknown Artist, Tel Aviv, Israel, 2013.
Photo by Julia Tulke

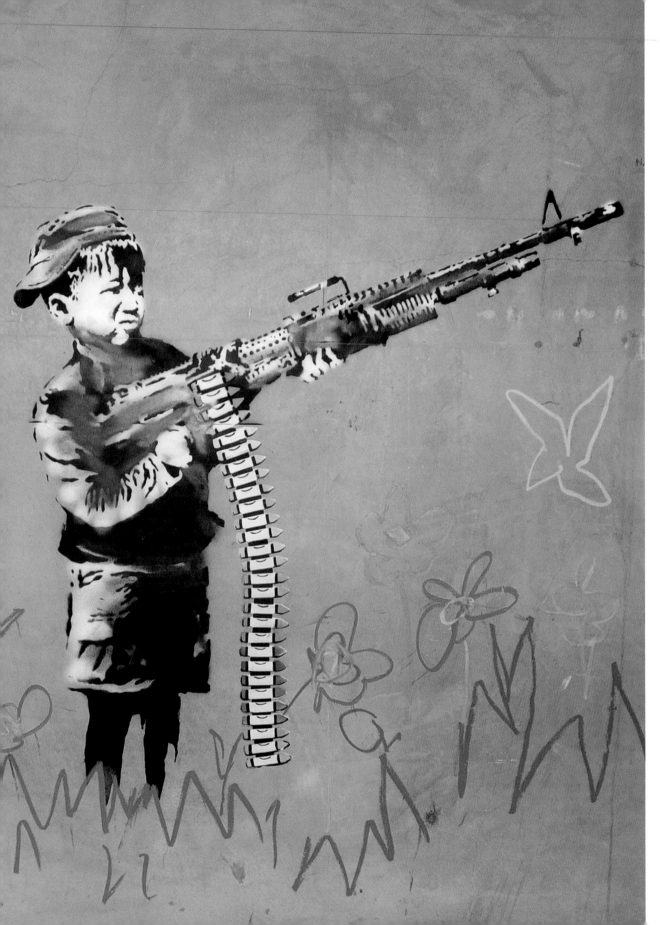

Left: Banksy, The Crayola Shooter, Los Angeles, California, USA, 2011.
© *Jason Laveris / FilmMagic / Getty Images*

Below left: Keizer, Grenade, Cairo, Egypt, 2011. Photo by Hend AbduAllah
Below right: Soon, Berlin, Germany, 2013. Photo by Julia Tulke

'Banksy is very intelligent and I feel an affinity to some of his ideas which tend to be more general critiques of society and the human race than attacks on politicians. He knew how to capture ideas that were floating in the air and thought of by many but he expressed them first.

RUN DONT WALK

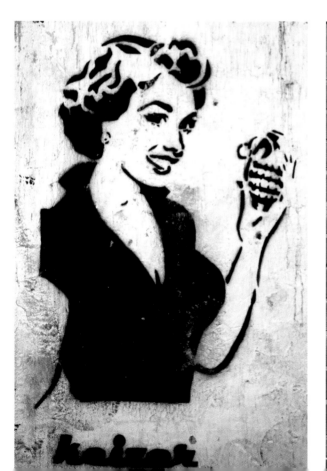

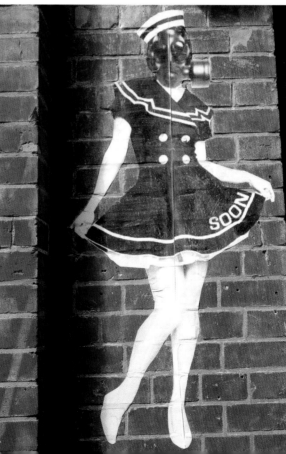

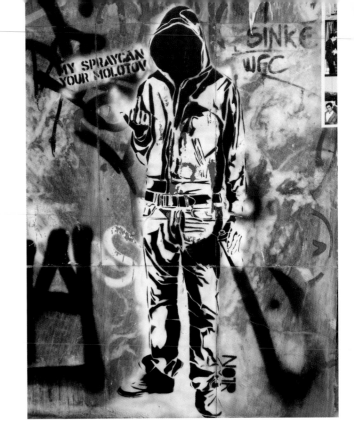

Right: Noir, My Spraycan Your
Molotov, Athens, Greece, 2013.
Photo by Julia Tulke
Below: Alias, Berlin, Germany, 2012.
Photo by Lucky Cat

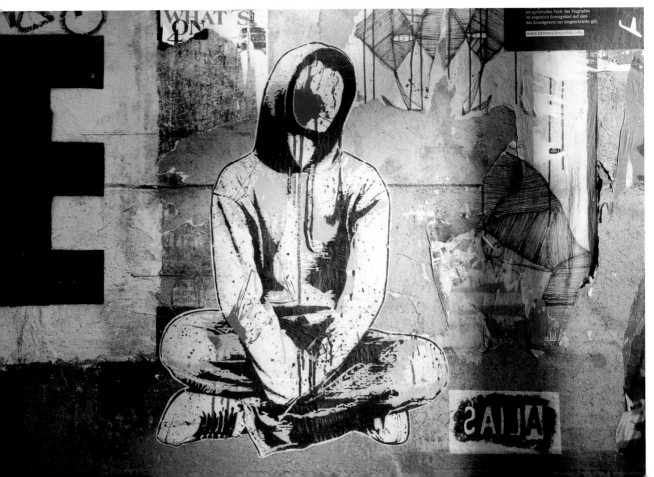

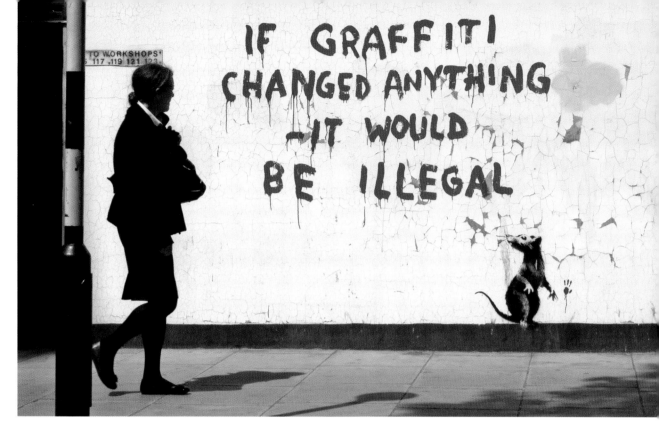

Above: Banksy, London, England, 2010.
Right: Banksy, London, England, 2007.
© Jenny Matthews / Alamy

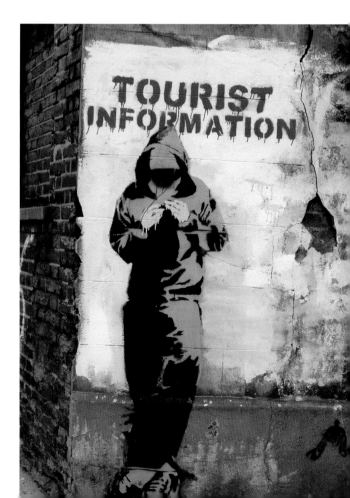

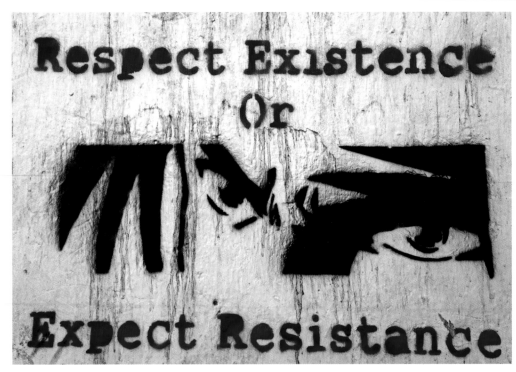

Above: Unknown, Cairo, Egypt, 2011.
Photo by Hend AbduAllah
Below: P183, Moscow, Russia, 2012.

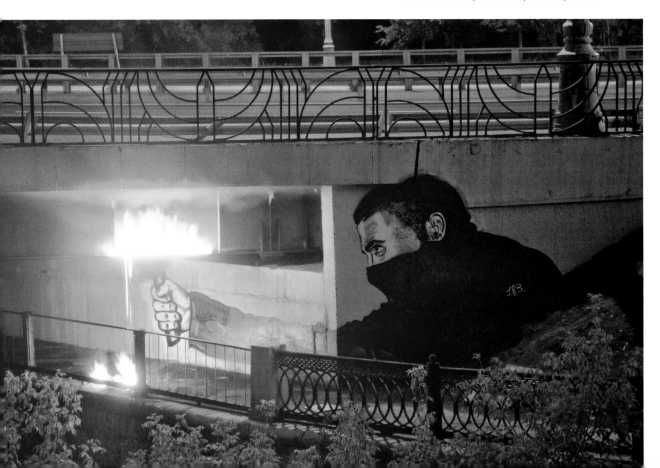

'Hardly any of us now, reaching for success, relationships, money, fame, is able to give up all of this. Burn the bridges and tear down all your achievements for the sake of a new, illogical, unknown, reckless life or death. This installation is dedicated to those who have gone beyond their own dusty corners and are able to single-handedly create a new world. Those who are capable of self-denial for the sake of a step forward.'

P183

Below left: Camo, Alexandria, NSW, Australia, 2012.
Below right: Toxicómano Callejero, Bogotá, Colombia, 2011.

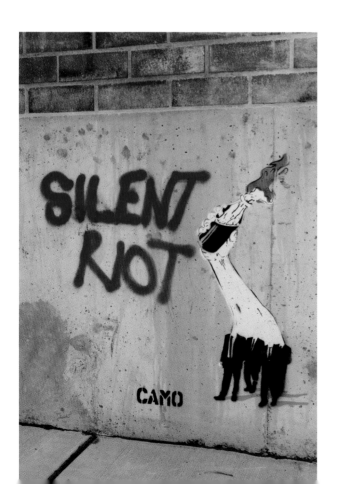

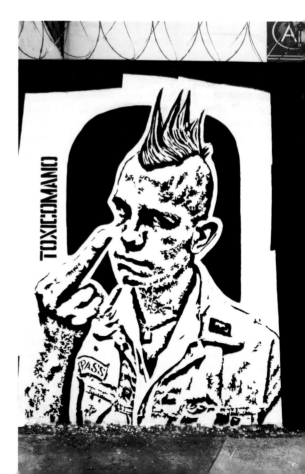

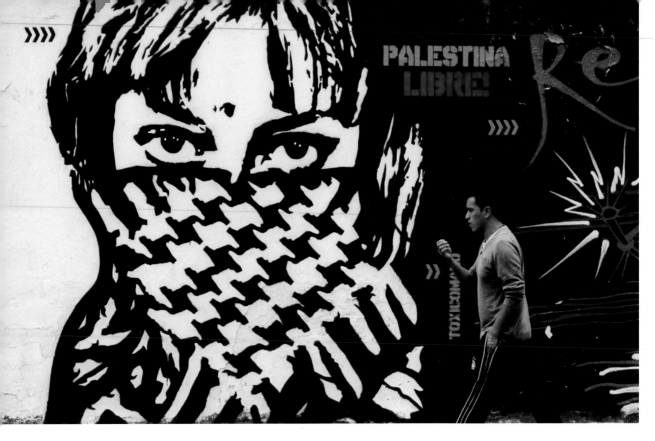

'A lot of the projects I do are related to socio-political situations not many people consider in their daily life, so it's a way of raising certain issues that other artists don't raise.'

#CODEFC

Top: Toxicómano Callejero, Bogotá, Colombia, 2011.
Above: Aiko, Tomioka Station, Fukushima, Japan, 2013.
Right: #codefc, South Vietnam, 2010.

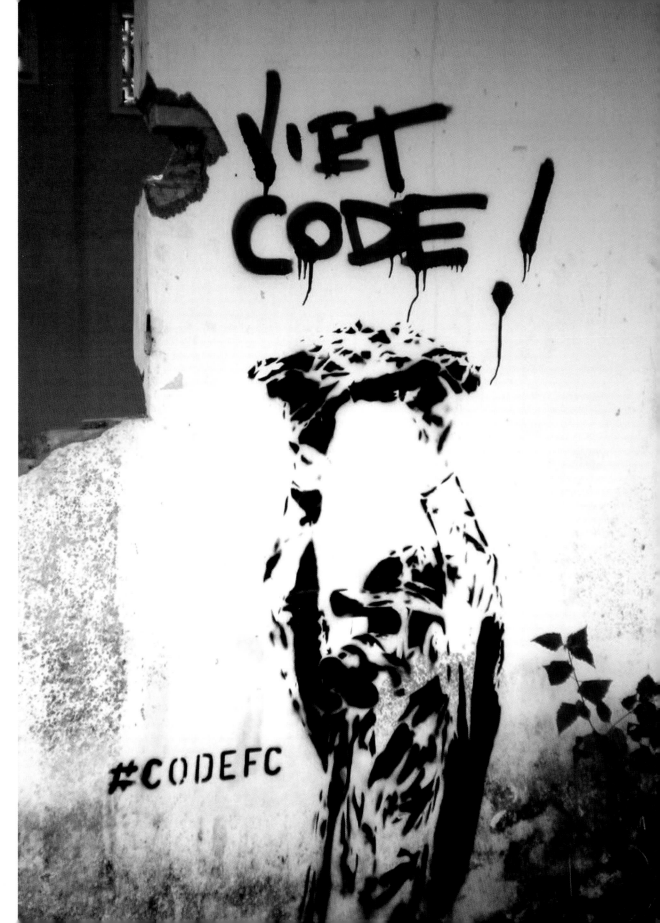

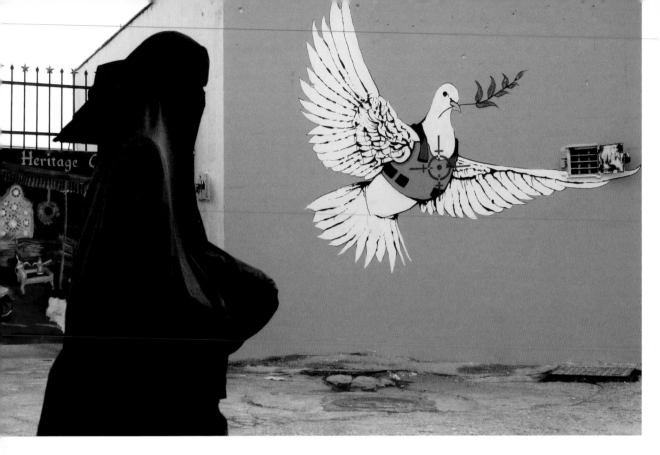

Above: Banksy, Bethlehem, 2007. © *REX / Sipa Press*
Right: ADW, Perched on Peace, Dublin, Ireland, 2011.

'I'm interested in attracting people's attention on a wall or a place they would never notice otherwise. Street art makes the daily and urban environment a bit more fun and interesting, and I'm definitely fighting for that cause.'

ZABOU

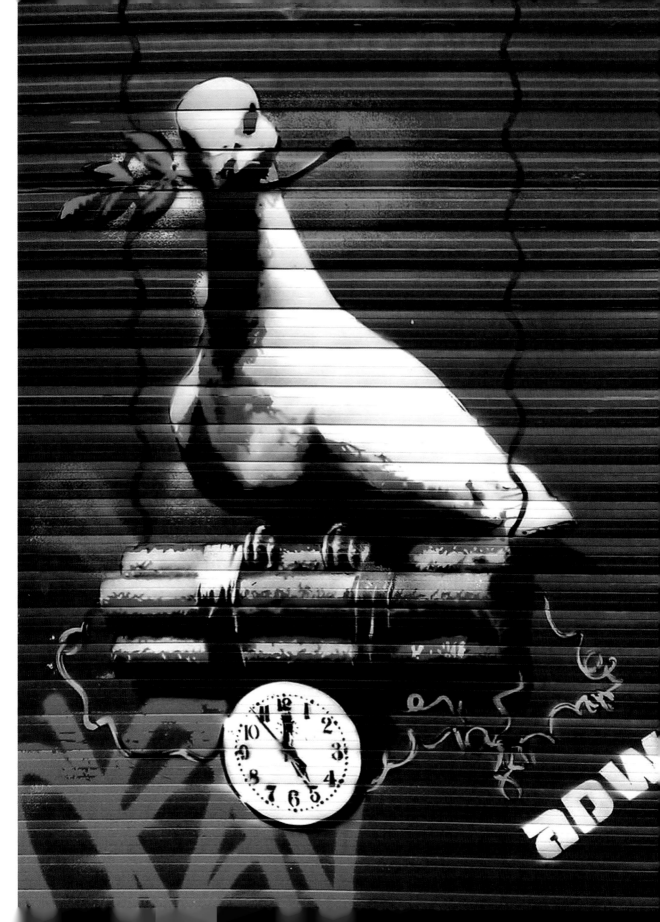

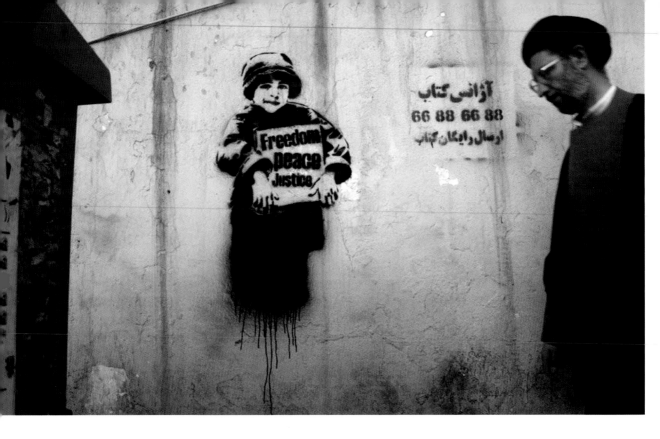

Above: Icy and Sot, Tehran, Iran, 2010.
Right: Sajjad Abbas, Baghdad, Iraq, 2011.

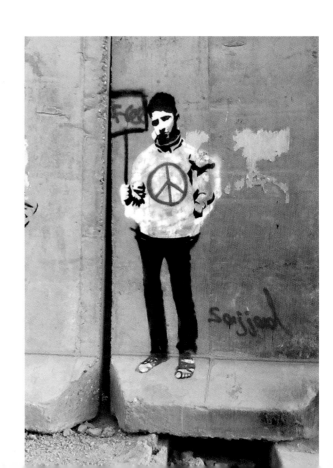

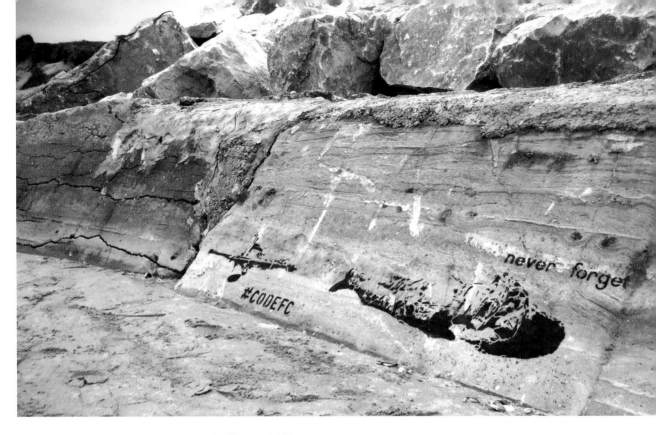

Above: #codefc, Utah Beach, Normandy, France, 2009.
Below: Various artists, including Robbie Conal, Free Humanity and
LA vs. War, Los Angeles, California, USA, 2011. Photo by KET

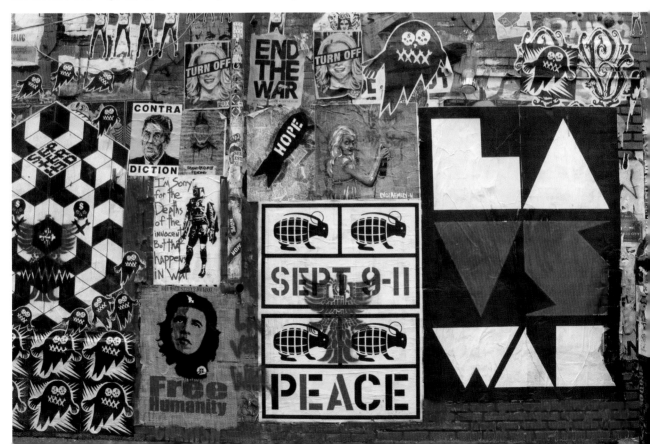

ꞃeatured artists

Above (USA/France)
www.goabove.com

-

ADW (Ireland)
www.adwart.com

-

Aiko (Japan/USA)

-

Alec Monopoly (USA)
www.alecmonopoly.com

-

Alias (Germany)

-

Aryz (Spain)
www.aryz.es

-

Banksy (England)

-

Bbrother (Taiwan)

-

Be Free (Australia)

-

Ben Eine (England)
www.einesigns.co.uk

-

BS.AS Stencil (Argentina)

-

Camo (Australia)

-

Canvaz (Ireland)

-

#codefc (England)

-

Common Cents (USA)

-

Cryptik (USA)
www.cryptik.com

-

Decycle (Germany)

-

Dede (Israel)

-

Destroy All Design (USA)

-

Dr D (England)
www.drd.nu

-

E.L.K (Australia)
www.elkstencils.com

-

Eelus (England)
www.eelus.com

-

Ender (France)

-

EPS (Lebanon)

-

Free Humanity (USA)

-

FRZ (Iran)

-

Hanksy (USA)
www.hanksy.com

-

Hogre (Italy)

-

Icy and Sot (Iran)
www.icyandsot.com

-

Jay Jasso (Mexico/USA)

-

Jerm IX (Canada)
www.jerm-ix.ca

-

Keizer (Egypt)
www.keizerstreetart.wix.com
-
Matias Espacial Picón
(Brazil)
-
Mogul (Sweden)
www.thinkmogul.com
-
Mr Brainwash (USA)
www.mrbrainwash.com

Noir (Germany)
-
Orticanoodles (Italy)
www.orticanoodles.com
-
Ozi (Brazil)
-
Pasha 183 (Russia)
-
Pegasus (England)
www.pegasusstreetart.com
-
Run Dont Walk (Argentina)

-
Sajjad Abbas (Iraq)
-
Skullphone (USA)
www.skullphone.com
-
Solus (Ireland)
www.solusstreetart.com
-
Soon (Germany)
-
Stewy (England)
-
T.Wat (England)
-
The Dotmasters (England)
www.dotmaster.co.uk
-
The Dude Company (France)
-
Tona (Germany)
tonastreetart.blogspot.co.uk
-
Toxicománo Callejero
(Colombia)

-
Wild Drawing (Greece)
www.wdstreetart.com
-
Zabou (England)
www.zabou.me
-
Zilda (Italy)
www.zildastreetart.com
-
Zuk Club Art Group (Russia)
www.zukclub.com
-

thank you

I would like to thank all the artists who are working in the streets illegally and clandestinely. Special thanks go to all the artists that have contributed images of their work to this book from all over the world. The response to my requests for images was tremendous and many artists did not make it into the book or decided against it. I would like to recognize some of these great artists because their work in the streets is important – Aiko, A1 One, Basco Vazco, Bleeps, Escif, Free Humanity, Pøbel, Poch, Piores Nada, Tona, and Stinkfish – thank you.

To all the photographers who are fans: Hend AbduAllah, Becki Fuller, Luna Park, Ray Mock, Julia Tulke, Hanna Lindgren, Erik Nehring, Tomas Olsson, Genia Zub4ik, and Lucky Cat – thank you for your contribution.

To my family for always believing in me: Andi, Talia, Xolo, and Aya. I love you, thank you.